SIGNIFIKANTE SIGNATUREN XVI

In the 'Significant Signatures' catalogue edition, the Ostdeutsche Sparkassenstiftung, East German Savings Banks Foundation, in collaboration with renowned experts in contemporary art, introduces extraordinary artists from the federal states of Brandenburg, Mecklenburg-Western Pomerania, Saxony and Saxony-Anhalt.

Mit ihrer Katalogedition »Signifikante Signaturen« stellt die Ostdeutsche Sparkassenstiftung in Zusammenarbeit mit ausgewiesenen Kennern der zeitgenössischen Kunst besonders förderungswürdige Künstlerinnen und Künstler aus Brandenburg, Mecklenburg-Vorpommern, Sachsen und Sachsen-Anhalt vor.

Ostdeutsche
Sparkassenstiftung

ELISABETH ROSENTHAL

vorgestellt von presented by
Monika Brandmeier

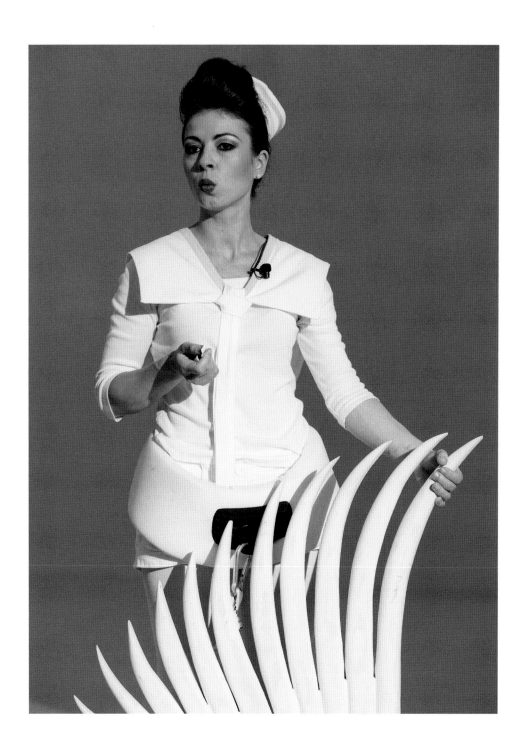

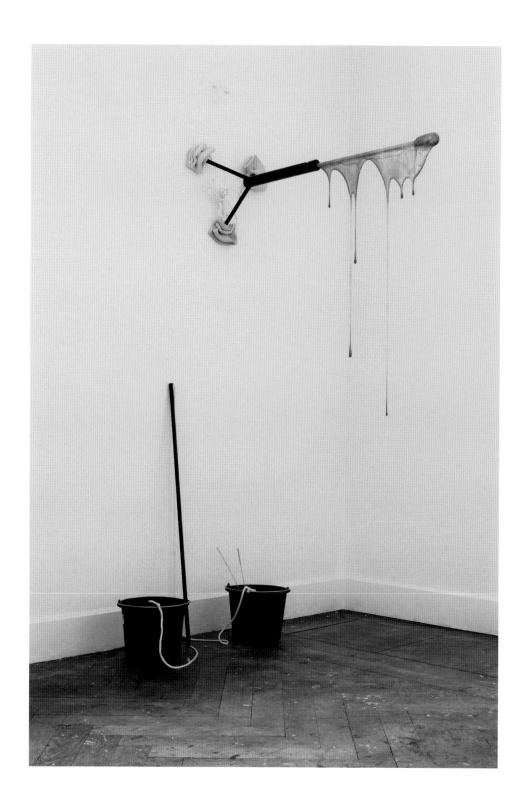

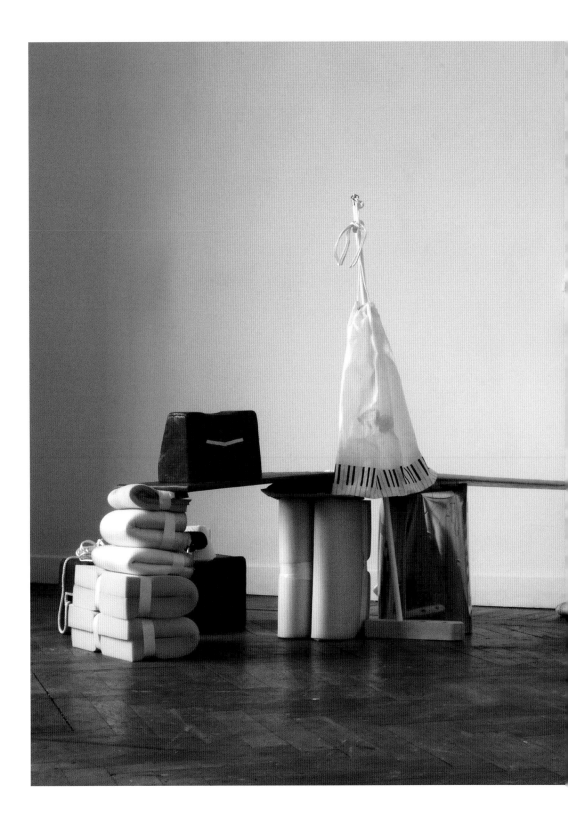

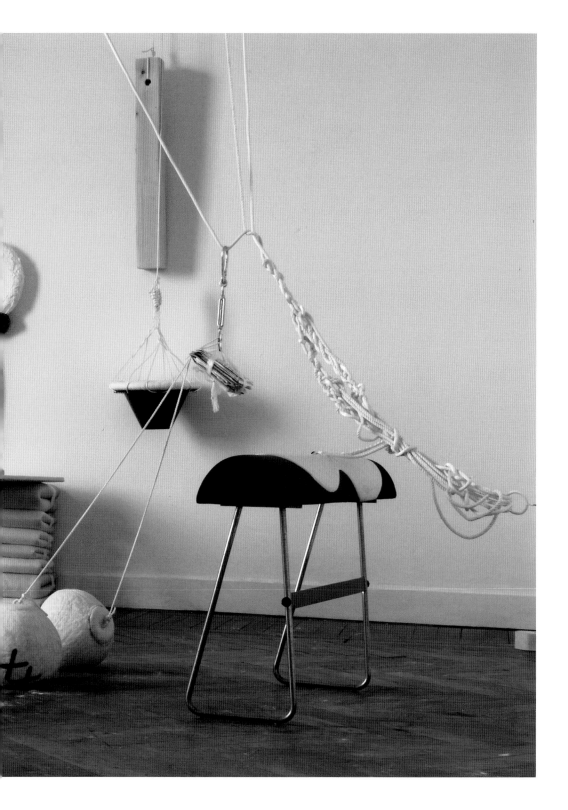

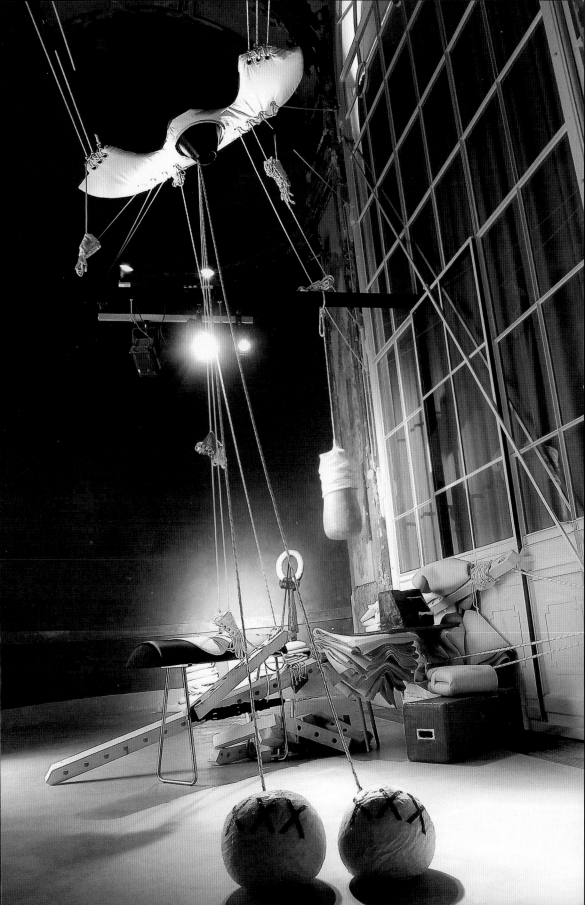

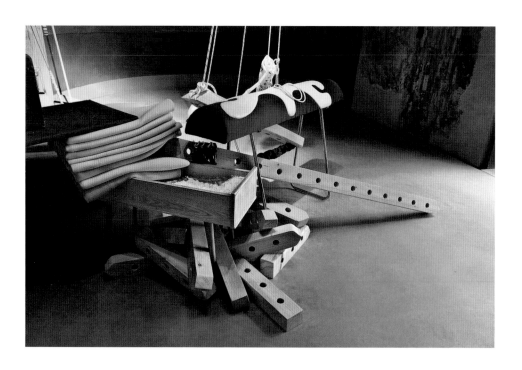

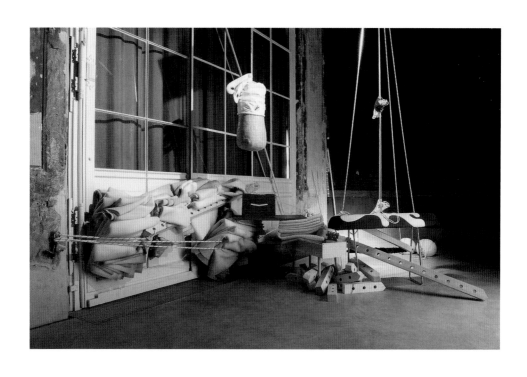

MONIKA BRANDMEIER AND ELISABETH ROSENTHAL 2015

MONIKA BRANDMEIER UND ELISABETH ROSENTHAL 2015

In your works you often use ropes and tethers, fenders and carabiner snap hooks. Do you like sailing?

No, but I imagine that I would feel very free on such a boat.

So what function do these things have? You use them not only in your large spatial installations but sometimes also in your performances. For example, there is a belt to which a snap hook is attached.

I use cords and ropes to indicate distances, to bring strength and also greater aggressiveness into the image. Individual objects are tied together with ropes and guyed down. Pulling, tensioning, squeezing. I had to find a simple way to pull numerous smaller components together into a compact structure and show how all the components belong together and are under control.

I remember a conversation with you. That was in 2007. I had packed many small sack-like padded objects close together. They seemed to tumble around; you could have played football with them. You said that they should perhaps be fixed down. I then decided to turn this fixing down into a pictorial medium. I added the carabiner snap hooks because I do not like loosely hanging rope ends and always like to set a point. I also like the sporting element. Such a snap hook is interesting because it is very convincing. You immediately believe in it, don't you?

In Deinen Arbeiten verwendest Du häufig Leinen und Taue, Fender und Karabiner. Segelst Du gern?

Nein, aber ich stelle mir vor, dass ich mich auf so einem Boot sehr frei fühlen würde.

Welche Funktion haben denn diese Dinge? Sie kommen ja nicht nur in den großen raumbezogenen Installationen vor, sondern auch manchmal in Deinen Performances. Es gibt beispielsweise einen Gürtel, in den ein Karabiner eingeklinkt wird.

Seile und Taue benutze ich, um Distanzen deutlich zu machen, Kraft und auch mehr Aggressivität ins Bild zu bringen. Einzelne Objekte werden mit Seilen aneinander festgebunden und verspannt. Ziehen, spannen, quetschen. Ich musste eine einfache Lösung dafür finden, wie ich viele kleinere Teile zu einem kompakten Gebilde zusammenziehen und sichtbar machen kann, sodass alle Teile zusammengehören und unter Kontrolle sind.

Ich kann mich an ein Gespräch mit Dir erinnern. Das war 2007. Da hatte ich viele kleine sackartige Polsterobjekte dicht zusammengestellt. Die schienen so rumzupurzeln, man hätte damit Fußball spielen können. Du sagtest, dass man die vielleicht festmachen müsste. Daraufhin habe ich entschieden, dieses Festmachen ein Bildmittel werden zu lassen. Die Karabiner habe ich noch dazu genommen, weil ich lose rumhängende Seilenden nicht mag und da immer gern einen Punkt setze. Außerdem finde ich das sportliche Element gut. So ein Karabiner ist interessant, weil er sehr überzeugend ist. Man glaubt das sofort, oder?

That's true, the snap hook reminds me of trapeze artists and mountaineers. It conveys something of the serious nature of a life-threatening situation.
Yes, but Sailor-Single also hangs on a rope and snap hook because it has to be treated like all the other objects. If it were not suspended in the installation, it would run away. Or the viewer would not be able to see that it belongs there.

Through the presence of ropes, the installations become more definite and the components are fixed in place. They appear more functional and less arranged, which is perhaps important because the materials are often so light. But they also provide Sailor-Single with a kind of working world. The components can function as props and be moved around. Indeed, the sculptures form a stage for your performances. Is it possible that your sculptures all have to be understood from this perspective?
All the objects that I construct are intended to form a space that can be used. Sailor-Single practically lives in this space.

And who is Sailor-Single?
Well, it is me, but in an extended form. I only have to put on the costume and direct light onto it, and then it is there. However, it also always requires an installation, or at least a lot of space, otherwise it does not contrast sufficiently with the rest of the room.

Stimmt, der Karabiner erinnert mich an Trapezkünstler und Bergsteiger. Er vermittelt ein wenig den Ernst einer Lebensgefahr.
Ja, aber das Sailor-Single hängt auch deshalb an Seil und Karabiner, weil es so wie alle anderen Objekte behandelt werden muss. Wenn es nicht in die Installation eingehängt wäre, dann würde es weglaufen. Oder der Betrachter könnte nicht sehen, dass es dazugehört.

Durch die Vertäuung werden die Installationen bestimmter und die Teile verschiebungssicher. Sie erscheinen funktionaler und weniger arrangiert, was vielleicht deshalb wichtig ist, weil die Materialien oft so leicht sind. Aber sie geben dem Single auch eine Art Arbeitswelt. Die Teile können als Requisiten fungieren und beweglich sein. Wie überhaupt die Skulpturen auch eine Bühne für Deine Performances bilden. Kann es sein, dass man alle Deine Skulpturen von diesem Ende her verstehen muss?
Alle Objekte, die ich baue, sollen einen Raum bilden, den man auch benutzen kann. Sailor-Single wohnt da praktisch drin.

Wer ist denn Sailor-Single?
Na das bin ich, aber erweitert. Ich muss nur das Kostüm anziehen und Licht draufsetzen, und dann ist es da. Allerdings gehört auch immer eine Installation dazu, zumindest sehr viel Platz, sonst setzt es sich nicht genug vom Rest des Raumes ab.

But this 'it', Sailor-Single, is not you, the sculptor, is it? It is a diva that adorns itself with plumes borrowed from you. It acts on your behalf, because it shows us how sculptures are to be treated and brings them to life, endows them with a soul, animates them. But doesn't Sailor-Single also have interests of its own?

Sailor-Single is my alter ego. It draws on my influences and predilections. That is why I said that Sailor-Single is an extension of myself. When I invented the character, I also tried to imagine how its life might have been hitherto. Perhaps it would be good to know which country it comes from, who its parents are and how it spent its childhood. But then I gave up that idea; it felt much too artificial. When Sailor enters the room, it is only there for a moment, and it disappears as soon as it leaves the room.

And what can Sailor do that you can't?

Sailor has autistic character traits, thinks quickly and moves in a very controlled way, being sparing with facial expressions and gestures, as in film acting. Sailor likes to play, in a very serious and disciplined way, and it works or trains. Sailor also like sleeping, dozes off or sucks its thumb.

What is Sailor referencing, what is it practising?

It is all about imitation and reminiscence. With Sailor I am trying to re-evaluate historical and cultural images. That is done in a simple and level-headed but also playful way. It is mostly funny. There are two works which deal with practising the piano.

Dieses ES, Sailor-Single, bist ja nicht Du, die Bildhauerin, oder? Es ist eine Diva, die sich mit Deinen Federn schmückt. Es handelt in Deinem Auftrag, weil es uns zeigt, wie die Skulpturen zu handhaben sind und lässt sie lebendig werden, beseelt, animiert. Aber hat Sailor-Single auch eigene Interessen?

Sailor-Single ist mein Alter Ego. Es schöpft aus meinen Einflüssen und Vorlieben. Deswegen meinte ich, dass Sailor-Single eine Erweiterung meiner selbst ist. Als ich mir den Charakter ausgedacht hatte, versuchte ich, mir auch einen Lebenslauf zu überlegen. Vielleicht wäre es gut zu wissen, aus welchem Land es kommt, wer die Eltern sind und wie es die Kindheit verbracht hat. Aber das habe ich wieder verworfen, es fühlte sich viel zu künstlich an. Wenn Sailor den Raum betritt, dann ist es ja nur in diesem Moment da und komplett verschwunden, wenn es den Raum verlässt.

Und was kann Sailor, was Du nicht kannst?

Sailor hat autistische Charakterzüge, denkt schnell und bewegt sich mimisch sehr beherrscht und gestisch sparsam, wie beim Filmschauspiel. Sailor spielt gern und zwar sehr ernsthaft und diszipliniert, es arbeitet oder trainiert. Sailor schläft auch gern, döst herum und nuckelt am Daumen.

Worauf bezieht sich Sailor, was übt es?

Es geht ums Imitieren und Erinnern. Mit Sailor versuche ich, historische und kulturelle Bilder zu verarbeiten. Das passiert einfach und nüchtern, aber auch verspielt. Meistens ist es lustig. Es gibt zwei Arbeiten, in denen es ums Klavierüben geht.

The first is called *Troubadix*. In that I am playing *Moments Musicaux*, Opus 94 in C sharp minor by Franz Schubert, on a painted keyboard, and the spectators only hear clicking sounds on the paper. I did a preliminary work on this theme during my time at college in London. I didn't have a piano there and I missed it very much. In the performance I had paint on my fingertips and was playing a prelude and fugue by Bach on the paper. I then tried to track each fingerprint and wrote numbers and notes next to each one. In the other work created in 2015 I improvise the baroque. That sounds completely weird. The fake piano keyboard is not really a new invention. It already existed in the days of Liszt. Travelling pianists took keyboards with them in order to practise during the journey. If you draw on inspired half-knowledge, interesting things can happen. I once heard a symphony by a Turkish composer who lived in the period around 1800, Hamamîzâde Ismail Dede Efendi (1778 – 1846). He composed in the style of contemporary European music, but performed it with traditional instruments from his own country. That sounds strange. It is well composed, but it still sounds peculiar.

The travelling pianist without a piano is a nice image. But why the lip-syncing shows? Isn't lip-syncing something for cowards?
Lip-syncing is for cowards or for people who can't sing. It is very popular in the drag scene. They want to be someone else, like Barbra Streisand or Liza Minelli. I have had a few such performances, always with a partner, a DJ, who decided what I should "sing" next.

Die erste heißt *Troubadix*. Da spiele ich *Moments Musicaux*, Opus 94 in cis-Moll von Franz Schubert auf einer gemalten Tastatur, und die Zuschauer hören nur das Klicken auf dem Papier. Eine Vorläuferarbeit dazu hatte ich 2001 während meiner Zeit am College in London gemacht. Ich hatte dort kein Klavier und habe es sehr vermisst. In der Performance hatte ich Farbe an den Fingerkuppen und spielte ein Präludium und eine Fuge von Bach auf Papier. Dann habe ich versucht, jeden Fingerabdruck nachzuvollziehen und entsprechend Nummern und Noten daneben geschrieben. In der anderen Arbeit von 2015 improvisiere ich Barock. Das klingt total schräg. Die Fake-Klaviertastatur ist eigentlich keine Neuerfindung. Die gab es zu Zeiten von Liszt schon. Reisende Pianisten haben Tastaturen mitgenommen, damit sie unterwegs üben können. Wenn man aus einem inspirierten Halbwissen schöpft, können interessante Dinge passieren. Ich habe mal eine Sinfonie von einem türkischen Komponisten um 1800 gehört, Hamamîzâde Ismail Dede Efendi (1778 – 1846). Der hat im Stile zeitgenössischer europäischer Musik komponiert, die aber mit traditionellen Instrumenten seines Landes aufgeführt. Das klingt eigenartig. Das ist gut komponiert, aber es klingt trotzdem komisch.

Der reisende Pianist ohne Klavier ist ein schönes Bild. Aber warum die Playbackshows? Ist Playback nicht eher was für Feiglinge?
Playback ist für Feiglinge oder für Leute, die nicht singen können. In der Travestieszene sehr beliebt. Die wollen jemand anderes sein, beispielsweise Barbra Streisand oder Liza Minelli. Ich habe ein paar solcher Aufführungen gehabt, immer mit einem Partner, einem DJ, der festgelegt hat, was ich als nächstes »singe«.

And so Sailor-Single has the desire to be someone else, and thus to have an alter ego of its own. In that connection, I notice how often idealised body parts appear in your works. The beautiful big white wing, the extra-long eyelashes of the trees, the decorative weights in your hands or the feathers on your hat. And then there are also the roofs which Sailor-Single climbs onto.
Sailor-Single first climbed onto a roof in 2008. Since then, a new roof photo has been produced every year, each time in a new place.

I would like to learn more about the objects and the narrative they produce. Apart from this remarkable belt by which it is tied, there are also plastic objects that look like pocket watches. What is the figure doing with its hands when it is not playing the piano?
There is, for example, a piece of wood. By coincidence, it looks like a slice of bread. I spread white silicon on it to make it look tasty. I later used this thing as a microphone in my lip-syncing shows. Then there is also a one and a half metre long "divining rod". These are two thin steel rods which are welded together along half their length.
I have these standing in front of me during my whistling performance and I keep them oscillating the whole time. This adds some movement to the still image, and it adds to the luring and flirting in the performance.

Sailor-Single hat also auch den Wunsch, jemand anderes zu sein, und damit selbst ein Alter Ego. In dem Zusammenhang fällt mir auf, wie häufig idealisierte Körperteile in den Arbeiten auftauchen. Der schöne große weiße Flügel, die überlangen Wimpern der Bäume, die dekorativen Gewichte in Deinen Händen oder die Feder am Hut. Und dann gibt es noch die Dächer, auf die das Sailor-Single steigt.
Aufs Dach ist Sailor-Single zum ersten Mal 2008 gestiegen. Seitdem gibt es jedes Jahr ein neues Dachfoto, immer an einem neuen Ort.

Ich würde gern noch mehr über die Gegenstände erfahren und die Erzählung, die sie auslösen. Neben diesem bemerkenswerten Gürtel, an den es angeleint wird, gibt es taschenuhrähnliche Kunststoffobjekte. Womit hantiert die Figur, wenn sie nicht gerade Klavier spielt?
Es gibt zum Beispiel ein Stück Holz. Es sieht zufälligerweise aus wie eine Scheibe Brot. Darauf hatte ich weißes Silikon geschmiert, damit es lecker aussieht. Dieses Ding habe ich bei meinen Playbackshows später als Mikrofon benutzt. Dann gibt es noch eine eineinhalb Meter lange »Wünschelrute«. Das sind zwei dünne Stahlstangen, die zur Hälfte zusammengeschweißt sind. Die habe ich bei meiner Pfeifperformance vor mir stehen und halte sie die ganze Zeit über in Schwingung. Dadurch gibt es im ruhigen Bild etwas Bewegung, und sie unterstützt das Locken und Flirten in der Performance.

When I first started working with Sailor there were only two of my "fenders" – the short lengths of timber with round holes. I used one in each hand as a weight. Now there are gradually more and more of them. I also use them as building blocks. For example, I create my "catwalk" out of them. What you call pocket watches are my mirror objects. They are there because in the beginning I used to start a performance by talking to my own mirror image. They look like toys for budgerigars. The birds start to talk because they think their mirror image is a friend. These objects exist in different sizes. The largest is one metre in diameter. It serves to involve the room, and also the spectators, in the installation in the form of a mirror image. Another object is a trolley on which I can place everything that I need for a small performance. Oh yes, and also nearly all my works include a black bucket somewhere, one of which I recently used as a handbag. Such a bucket is a fantastic object. I like using them because it is interesting that due to their extensive use in everyday life we can no longer appreciate how beautiful they are. And that is the case with many objects, don't you think?

Von meinen »Fendern« – den kurzen Balkenstücken mit den runden Löchern – gab es am Anfang meiner Arbeit mit Sailor zunächst nur zwei. Ich hatte je eins in jeder Hand als Gewicht benutzt. Jetzt werden es nach und nach mehr. Ich benutze sie auch als Bausteine. Zum Beispiel lege ich mir daraus meinen »Catwalk«. Was Du Taschenuhren nennst, das sind meine Spiegelobjekte. Die gibt es, weil ich anfangs in einer Performance mit meinem eigenen Spiegelbild gesprochen habe. Sie sehen aus wie die Spielzeuge für Wellensittiche. Die Sittiche beginnen zu sprechen, weil sie ihr Spiegelbild für einen Freund halten. Diese Objekte gibt es in verschiedenen Größen. Das größte hat einen Durchmesser von einem Meter. Es dient dazu, den Raum und auch die Zuschauer als Spiegelbild in die Installation mit aufzunehmen. Ein anderes Objekt ist ein Trolley, in den ich alles reinladen kann, was ich für eine kleine Performance brauche. Ja, und außerdem tauchen in fast allen Arbeiten irgendwo schwarze Baueimer auf, von denen ich zuletzt einen als Handtasche benutzt habe. So ein Eimer ist ein tolles Objekt. Ich benutze die gern, weil es interessant ist, dass wir durch deren inflationären Gebrauch im Alltag gar nicht mehr sehen können, wie schön die sind. So ist das mit vielen Objekten, nicht?

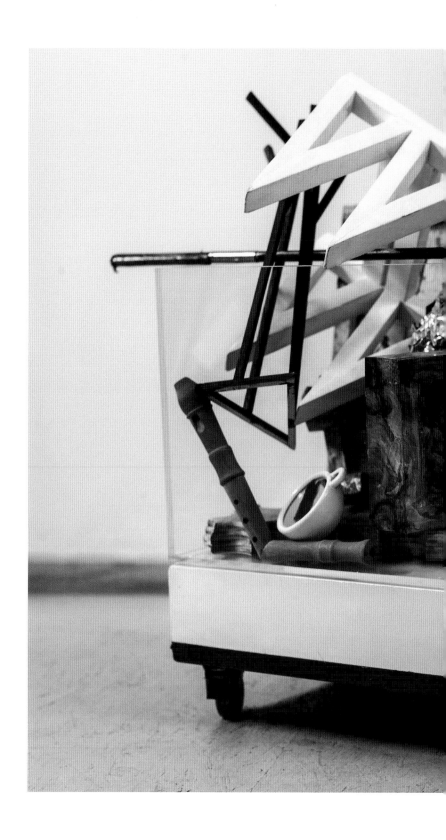

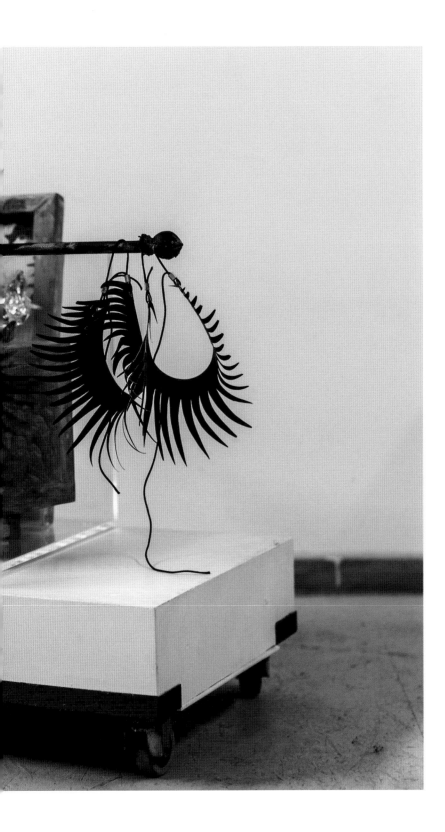

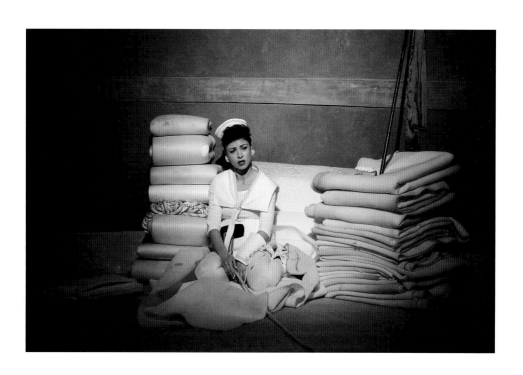

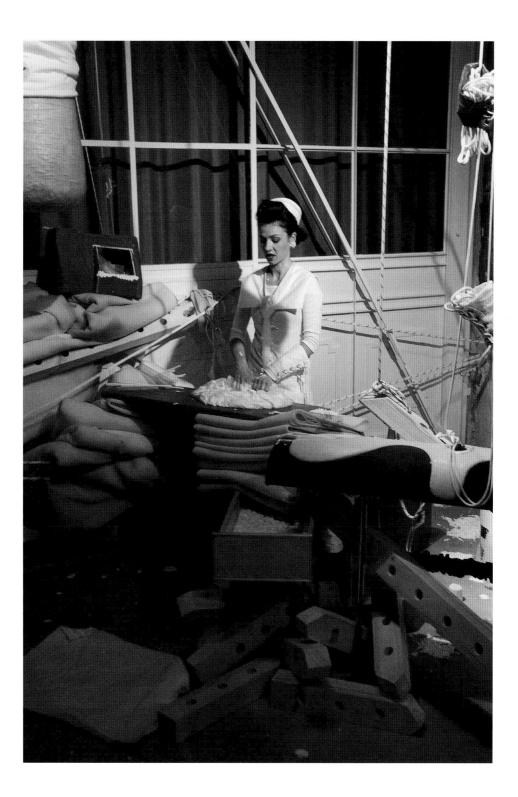

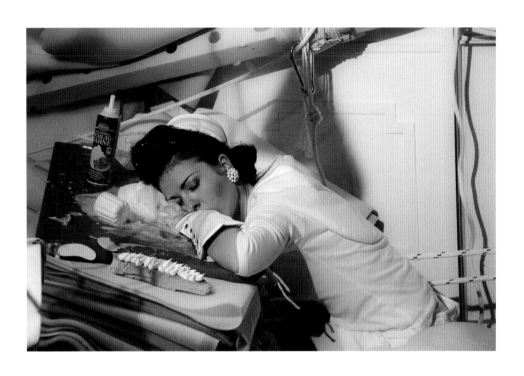

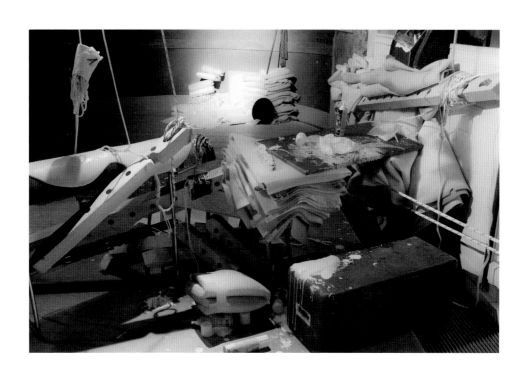

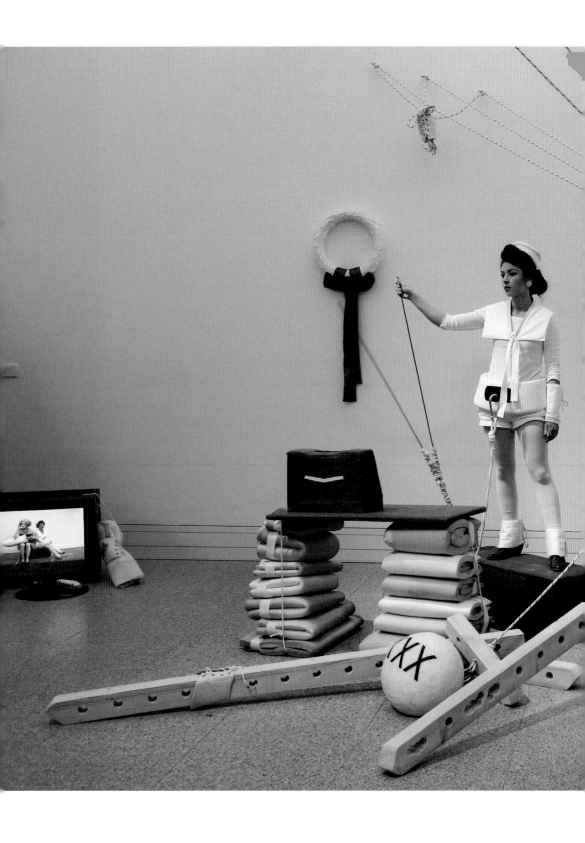

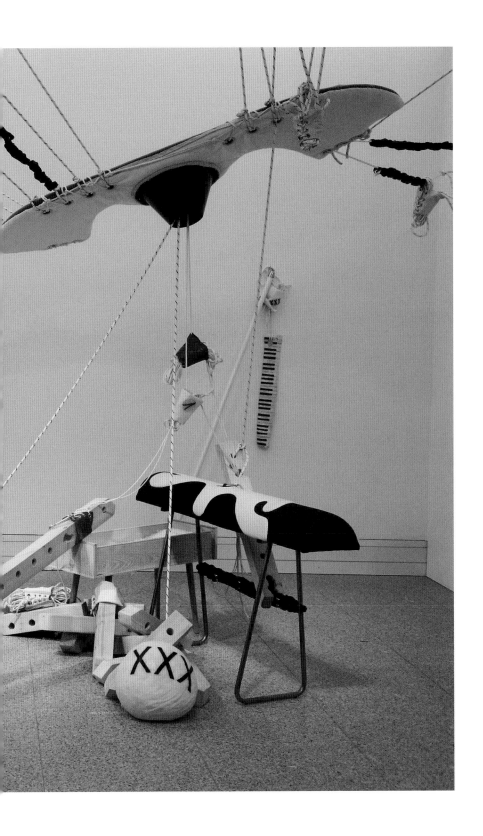

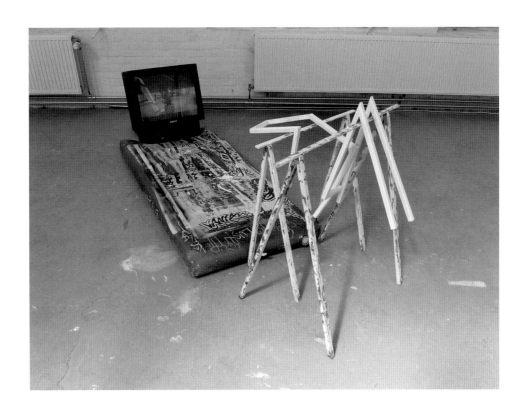

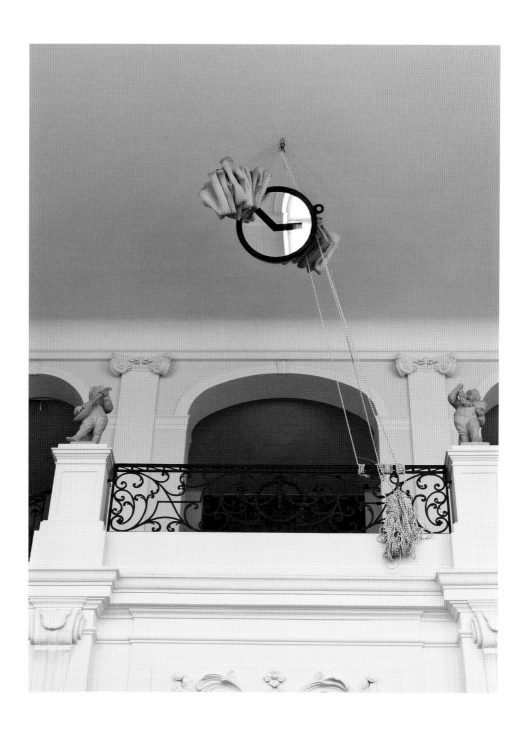

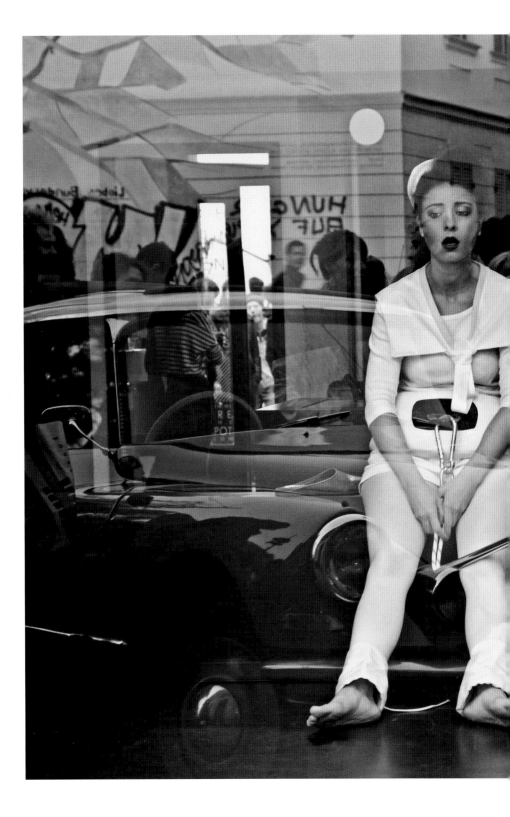

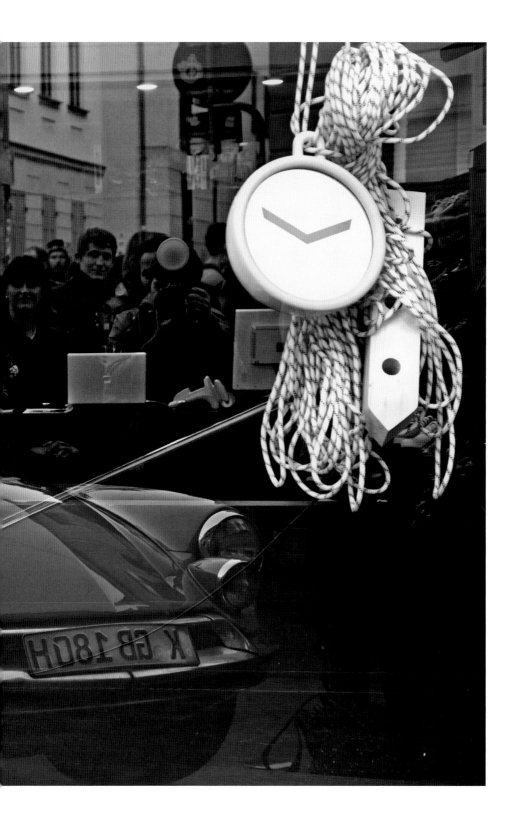

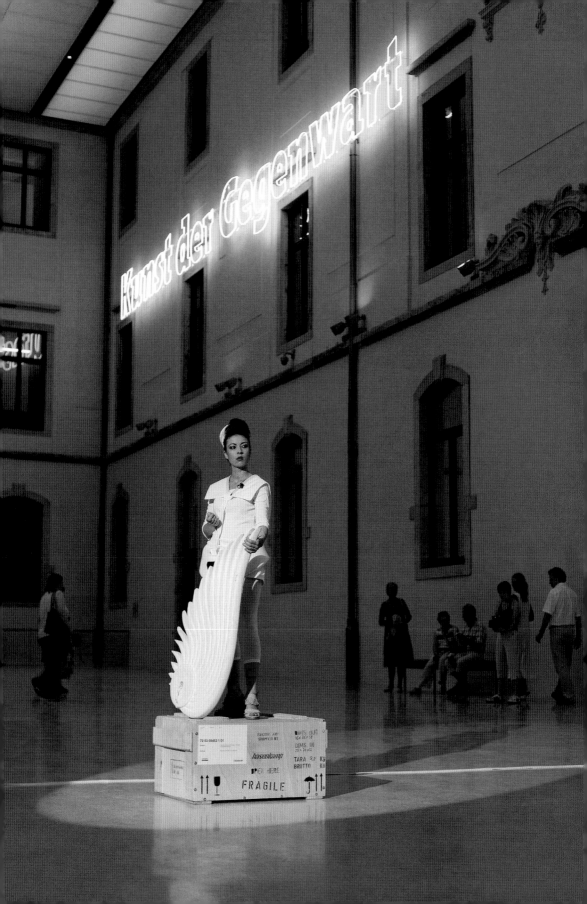

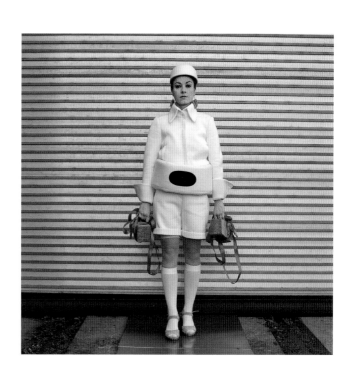

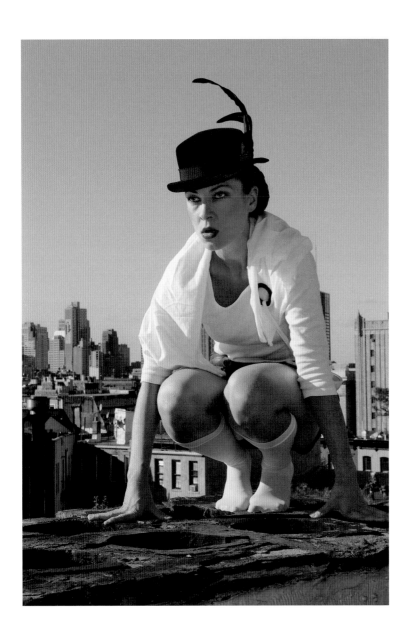

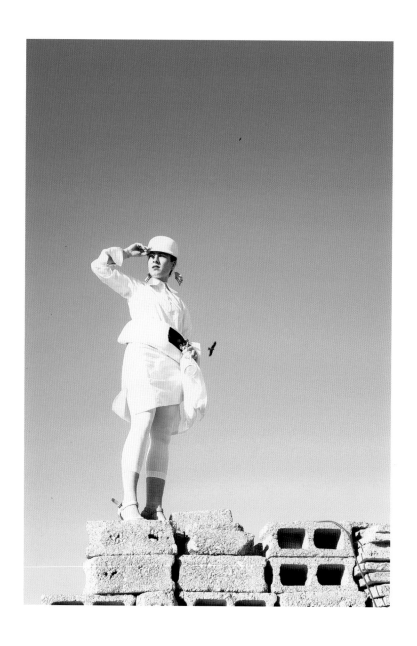

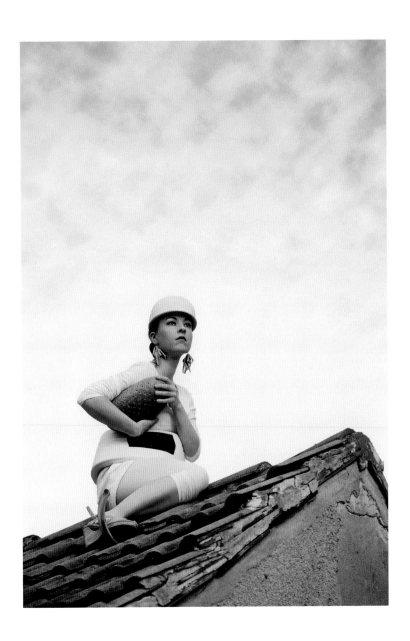

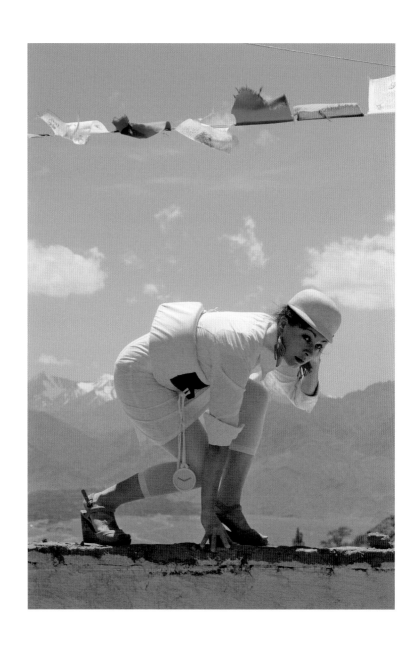

SAVE YOURSELF IF YOU WILL

REFLECTIONS ON THE WORK OF ELISABETH ROSENTHAL

RETTE SICH WER WILL

ÜBERLEGUNGEN ZUM WERK VON ELISABETH ROSENTHAL

In his famous *Treatise on Water* Leonardo da Vinci describes "a method of escaping in a tempest and shipwreck at sea". To save yourself, he writes, you need "a coat made of leather, which must be double across the breast, that is having a hem on each side of about a finger's breadth. Thus it will be double from the waist to the knee; and the leather must be quite air-tight. When you want to leap into the sea, blow out the skirt of your coat through the double hems of the breast, […] and allow yourself to be carried by the waves; when you see no shore near, give your attention to the sea you are in".[1] His recommendation to pilots in the rather likely event of a crash adheres to much the same principle. An inflatable ring, so he posits in *Codice sul volo degli uccelli* (1505), should prevent the worst.[2] For Leonardo, whose sketches of lifebelts are the oldest to have come down to us, such safety devices – such insignia of potential failure – were the foremost attribute of any would-be adventurer. Indeed, the proto-modern hero of his flights of discovery bore neither sword nor shield, but rather wings or fins and some manner of harness. No lifebelt, no glory.

Auf welche Weise man sich »bei einem Sturm oder Schiffbruch in Sicherheit bringen kann«, erklärt Leonardo da Vinci (1452 – 1519) in seinem berühmten *Wasserbuch*: Man brauche »ein Gewand aus Leder, das um die Brust herum doppelte Säume hat, die einen Finger breit sind, und auch vom Gürtel bis zu den Knien sollte es doppelt sein, und das Leder darf nichts durchdringen lassen. Und wenn Du ins Meer springen müßtest, dann blase durch die Säume auf der Brust die Schöße deines Gewandes auf und spring ins Meer und laß dich von den Wellen treiben, wenn du in der Nähe kein Land siehst und dich auf diesem Meer nicht auskennst«.[1] Ähnlich liest sich seine im *Codice sul volo degli uccelli* (1505) formulierte Empfehlung für Fliegende im damals noch wahrscheinlichen Falle eines Absturzes: Ein aufblasbarer Ring sollte das Schlimmste verhindern.[2] Für Leonardo, dessen Rettungsgurtskizzen als die ältesten uns bekannten gelten, waren derartige Schutzmittel, solche Insignien eines potenziellen Scheiterns, das wesentliche Attribut eines jeden Abenteurers. Die protomodernen Helden seiner Erkundungsfantasien trugen weder Schwert noch Schild, sondern Flügel oder Flossen und ein wie auch immer geartetes Geschirr. Ohne Rettungsring kein Ruhm.

Elisabeth Rosenthal's Sailor-Single seems to embody this early message to modern human beings in their quest to reach the highest and deepest and farthest corners of the universe. It is emblematised by her 2010 photograph *Glory*, in which the artist's alter ego, holding a large white wing, poses in front of a bright orange freight container emblazoned with the word "GLORY". At once sailor and figurehead, angel and siren, the solo traveller at the core of Rosenthal's artistic practice wears her lifebelt in a manner both proud and matter-of-fact. The same can be said of the rope that – contrary to the severed umbilical cord it evokes – could be attached to anything, anywhere, at any time, if the going were to get tough. For all the metamorphoses of her predominantly white uniform, and for all the variety of her stylised equipment, Sailor-Single never goes without her belt. Indeed, without this endlessly enabling marvel of modern technology – and its inadvertent invocation of failure – Rosenthal's complex persona never embarks on a voyage. Yet what is the nature of her journey? And where might it take her and us?

Diese frühe Botschaft für den in die Höhen und Tiefen und Weiten der Welt strebenden modernen Menschen scheint sich Elisabeth Rosenthals Sailor-Single einverleibt zu haben. Emblematisch hierfür ist das 2010 entstandene Bild *Glory*, auf dem das Alter Ego der Künstlerin mit einem großen weißen Flügel vor einem knallorangefarbenen, den unverfrorenen Schriftzug »GLORY« tragenden Überseecontainer posiert. Zugleich Matrose und Galionsfigur, Engel und Sirene, trägt die im Mittelpunkt von Rosenthals künstlerischer Arbeit stehende Alleinreisende ihren Rettungsgurt stolz und selbstverständlich. Ebenso das daran gebundene Seil, das sich – anders als die durchtrennte Nabelschnur, an die es erinnert – im Fall der Fälle überall und jederzeit festbinden ließe. Bei allen Verwandlungen seiner vorwiegend weißen Uniform, bei aller Vielfalt seiner stilisierten Gerätschaften verzichtet das Sailor-Single nie auf den Gurt. Ohne dieses alles Mögliche ermöglichende, das Scheitern stets mitschwingen lassende Wunderwerk macht sich die komplexe Persona nicht auf den Weg. Doch auf welchen Weg begibt sie sich? Wohin geht die Reise?

Up on the roof, to begin with. Like Leonardo, who kept his eye on the birds for years in the hope of one day emulating their flight, Sailor-Single ever and again finds herself drawn to the haunts and habits of winged creatures. Whether the sun is shining, or snow is falling, Rosenthal's seemingly nostalgic explorer perches up high in the otherwise seldom frequented places favoured by birds. Caught up in a process of perpetual fledging, Sailor-Single adopts multifarious avian poses. As attested by the artist's roof photo series, begun in 2008, she is fascinated less by the mechanics and mathematics of flight than she is by feathered existence per se. What appears to so reliably capture Rosenthal's attention is the lingering of birds in improbably precarious places, their sublime perspective, their profound knowledge of materials, their cheerful will to rearrange their environment, their unbridled freedom of movement and, at the same time, their unabashedly imitation- and variation-based interaction with one another. One bird calls, another one answers. And thus – as the artist shows in *Birdywork*, performed several times since 2008 – a conversation ensues. This nuanced exchange between all manner of voices renders palpable not only the inherently mimetic nature of human communication and action, but also the social and productive relationship that exists between imitation and creativity, between the grasping and making of worlds that forms the basis of Elisabeth Rosenthal's artistic practice.

Zunächst einmal aufs Dach: Ähnlich Leonardo, der in der Hoffnung, das Fliegen der Vögel eines Tages nachahmen zu können, über Jahre das Federvieh im Blick behielt, zieht es das Sailor-Single immer wieder zu den Vögeln. Bei Sonnenschein oder Schneefall hockt Rosenthals nostalgisch wirkende Entdeckungsreisende an den ganz weit oben gelegenen, von Menschen selten frequentierten Aufenthaltsorten der Vögel. Hier nimmt das in einem ewigen Prozess des Flüggewerdenwollens begriffene Sailor-Single die verschiedenartigen Posen der Vögel ein. Wie die seit 2008 entstehenden Dachfotos der Künstlerin veranschaulichen, faszinieren sie dabei weniger die Mechanik und Mathematik des Fliegens als das gefiederte Dasein. Was Rosenthals Aufmerksamkeit so verlässlich zu fesseln scheint, sind das Verweilen der Vögel an unwahrscheinlich prekären Orten, die Erhabenheit ihrer Perspektive, ihre ausgefeilten Materialkenntnisse, ihr fröhlicher Umgestaltungswille, ihre unendliche Bewegungsfreiheit, aber auch ihre ungeniert auf gegenseitiger Nachahmung und Variation beruhende Interaktion. Ein Vogel ruft. Ein anderer ruft zurück. Dabei entsteht – so zeigt es die Künstlerin in ihrer mehrfach seit 2008 aufgeführten Zwitscherperformance *Birdywork* – ein Gespräch. An diesem nuancierten Austausch zwischen vielerlei Stimmen wird nicht nur das inhärent Mimetische menschlicher Mitteilungen und Handlungen erfahrbar, sondern auch der ebenso soziale wie spannungsreiche Zusammenhang zwischen Nachahmung und Kreativität, zwischen dem Begreifen und dem Erschaffen von Welten, der Elisabeth Rosenthals Kunst zugrunde liegt.

In the artist's performance installations, sailing the seven seas of imitation proves an equally complex and creative endeavour. Whether we consider the *Arbeitsplatz* (Workplace) she installed in 2008 at the Hochschule für Bildende Künste in Dresden or the *Archiv* (Archive) she conceived in 2015 for the Kunsthalle HGN in Duderstadt, there is a palpable tension in her work between the frequently referenced topoi of cultural history and the processual aspects of chance, between well-rehearsed actions and formal innovation. On the one hand, we invariably find Sailor-Single at the helm. Her pantomimic facial expressions and gestures are similarly prescribed. Her costume, poised between film star and fetish, is an integral part of each performance. Fancy, chauffeur-driven motor cars are her transport of choice; snap hooks and ropes her faible. And wherever she goes, she seems to encounter a familiar repertory of flotsam and jetsam: mattresses, plastic buckets, foam mats and wooden blocks. Yet, on the other hand, for all the recurring elements we might encounter, the role of the shipwrecked showgirl is always a new one. Her stage is forever shifting, as are the challenges of the performance and the sculptural objects with which she surrounds herself. In the highly artificial world of the sailor – an environment under constant reconstruction – there emerges a dynamics of perpetual rehearsal, a culture of skilful unfinishedness, an aesthetic of "failing again" and "failing better" that would inevitably invoke Samuel Beckett[3] were the whole thing not so delightfully camp.[4]

Die sieben Weltmeere der Nachahmung zu befahren, erweist sich in den Performance-Installationen der Künstlerin als ein gleichermaßen komplexes wie schöpferisches Unterfangen. Ob man nun ihren 2008 an der Dresdner Hochschule für Bildende Künste eingerichteten *Arbeitsplatz* oder ihr 2015 für die Kunsthalle HGN, Duderstadt, konzipiertes *Archiv* in den Blick nimmt: Die Spannung zwischen den in ihrer Arbeit vielzitierten Topoi der Kulturgeschichte und den prozesshaften Momenten des Zufalls, zwischen erprobten Handlungen und formaler Innovation ist deutlich zu spüren. Zwar steht das Sailor-Single ausnahmslos am Steuer. Vorgegeben sind seine pantomimische Mimik und Gestik. Sein zwischen Filmstar und Fetisch schillerndes Kostüm ist fester Bestandteil eines jeden Auftritts. Gern lässt sich das Sailor-Single in heißen Schlitten chauffieren. Lieb sind ihm Karabiner und Seil. Und wo sie auch hingeht, findet die Figur ein Repertoire an Treibgut vor: Matratzen, Plastikeimer, Schaumstoffmatten, Holzklötze. Doch bei allen wiederkehrenden Elementen ist die Rolle des schiffbrüchigen Showgirls stets eine neue. Seine Bühne verändert sich ständig, ebenso die Herausforderungen des Spiels und die skulpturalen Gegenstände, mit denen die Figur sich umgibt. In der hochartifiziellen, immer wieder neu zusammengesetzten Welt des Sailors entsteht so eine Dynamik des ewigen Probens, eine Kultur des gekonnten Unfertigen, eine Ästhetik des Anders-und-besser-Scheiterns, die einen unweigerlich an Samuel Beckett[3] denken ließe, wenn sie nicht so herrlich Camp[4] wäre.

Even if Sailor-Single hadn't impersonated camp icon Carmen Miranda – see *The Lady in the Tutti Frutti Hat* (1943) – on several occasions, it would be hard to overlook Rosenthal's affinity for this mode of aesthetic experience. Her affection for the artificial and popular, for glamour and hyperbole, makes everything she does in the context of her artistic practice, whether its playing a paper piano or lip-syncing golden oldies, appear in quotation marks. She turns a clock into a "clock", as it were, or a woman into a "woman", to cite Susan Sontag's example in her seminal *Notes on "Camp"* (1964). The artist conceives of being and existence as "playing a role". She theatricalises experience.[5] And, in her charmingly non-didactic manner, she explores what, since Judith Butler, has come to be known as the performativity of gender.[6]

Despite the artist's overt affection for the camp sensibility, one cannot help but wonder whether Rosenthal's alter ego is not about more than mere role play, about more than the proposition of a consistently aesthetic experience of the world, or the contestation of social norms. For in contrast to the travesties of a "femme queen", the artist's project is both universal in scope and worldmaking. In her interrogation of imitation, which she articulates in all the media available to the visual arts, everything is at stake. Of primary importance is the creation of new forms, emergence, becoming. Indeed, the artist's sea may well be imagined and her sailor modelled on a pin-up girl, yet the indispensable lifebelt worn by Sailor-Single seems less ironic than heroic. Like Arthur Rimbaud's *Drunken Boat*, Rosenthal's

Selbst wenn das Sailor-Single nicht bereits mehrfach in die Rolle der als Paradebeispiel des Camp gefeierten Carmen Miranda geschlüpft wäre, siehe *The Lady in the Tutti Frutti Hat* (1943), wäre Rosenthals Affinität für diesen Modus der ästhetischen Erfahrung nicht zu übersehen. Ihre Zuneigung zum Künstlichen und Populären, zum Glamourösen und Übertriebenen lässt alles, was sie im Rahmen ihrer künstlerischen Arbeit macht und tut, sei es Papierklavier spielen oder Playback singen, gleichsam in »Anführungsstrichen« erscheinen. Sie macht eine Uhr zu einer »Uhr« oder, um das Beispiel Susan Sontags in ihren wegweisenden *Anmerkungen zu »Camp«* (1964) zu zitieren, eine Frau zu einer »Frau«. Sie begreift das Sein als das »Spielen einer Rolle«. Sie theatralisiert, wenn man so will, das Dasein.[5] Nicht zuletzt verweist sie – auf ihre reizend undidaktische Art – auf die seit Judith Butler als fast allgemein verstandene Performativität des Geschlechts.[6]

Bei aller Liebe der Künstlerin zum Camp stellt sich die Frage, ob es bei Rosenthals Alter Ego nicht um viel mehr geht als ein reines Rollenspiel, um mehr als einen Modus, eine konsequent ästhetische Erfahrung der Welt zu verfechten oder gesellschaftliche Normen zu hinterfragen. Denn im Gegensatz zu den Travestien einer »Femme Queen« ist das Projekt der Künstlerin universal angelegt und weltbildend. In ihrer sich in allen Medien der Kunst artikulierenden Auseinandersetzung mit der Nachahmung geht es ums Ganze. Wesentlich sind dabei die Schöpfung neuer Formen, die Entstehung, das Werden. Zwar mag das Meer imaginiert und ihr Matrose einem Pin-up-Girl nachempfunden sein. Doch wirkt der unabdingbare Rettungsring des Sailor-Single weniger ironisch als heroisch. Wie Arthur Rimbaud (1854 – 1891) mit seinem *Trunkenen Schiff*

solo traveller embodies a special model of crea-
tivity. In the work of the artist, the Romantic met-
aphor of the sea passage as a process of subjec-
tification similarly gives way to a new metaphor
of formulation. Rosenthal's "I" is also "another",[7]
a Sailor-Single who doesn't think, but is thought,
who is less concerned with reflecting on the
world around her than with taking part in the
processes that make up that world, by means of
imitation, creation and transformation.

Catherine Nichols
Translated from the German by the author

1 Leonardo da Vinci, *The Da Vinci Notebooks*
(London: Profile Books, 2005), 129.
2 See Blanche Stillson, *The Labours of Leonardo da Vinci*,
in *Wings: Insects, Birds, Men* (Indianapolis and New York:
Bobbs Merrill: 1954), 201–213 at 210.
3 See Samuel Beckett's late prose piece *Worstward Ho*
(1983), in *Nohow On: Company, Ill Seen, Ill Said,
Worstward Ho* (New York: Grove Press, 1996), 87–116 at 89.
4 Susan Sontag describes this "post-dandy" phenomenon
as a "love of the unnatural: of artifice and exaggeration",
as a sensibility that finds the "success in certain passionate
failures", as a preference for surfaces, imitation and travesty.
See Sontag, *Notes on "Camp"* (1964), in *Against Interpretation*
(London: Vintage, 1994), 275–292 at 275, 280, 291.
5 Ibid., 286.
6 See Judith Butler, *Gender Trouble: Feminism and the Subver-
sion of Identity* (1990) (London and New York: Routledge, 2006).
7 The famous sentences "Je est un autre" and "C'est faux
de dire: je pense. On devrait dire: on me pense" appeared in
Rimbaud's *Lettres du Voyant* (1871), see Arthur Rimbaud,
Complete Works, Selected Letters, trans. Wallace Fowlie (Chi-
cago and London: University of Chicago Press, 1966), 302–311.

hat Rosenthal mit ihrem Alleinreisenden ein
besonderes Kreativitätsmodell im Visier. In ihrer
Arbeit weicht die aus der Romantik hervorgegan-
gene Metapher der Schiffsreise als Subjektwer-
dung einer neuen Metaphorik der Formwerdung.
Rosenthals »Ich« ist auch »ein anderer«,[7] ein
Sailor-Single, das nicht denkt, sondern gedacht
wird, das sich und die Welt um sich herum weni-
ger reflektiert als sich nachahmend, mit- und
umgestaltend an ihren Prozessen zu beteiligen.

Catherine Nichols

1 Leonardo da Vinci, *Das Wasserbuch. Schriften und Zeichnun-
gen*, ausgewählt und übersetzt von Marianne Schneider, Mün-
chen u. a. 1996, S. 75.
2 Vgl. Blanche Stillson, *The Labours of Leonardo da Vinci*, in:
dies., *Wings. Insects, Birds, Men*, Indianapolis/New York 1954,
S. 201–213, hier S. 210 und Leonardo da Vinci, *Der Vögel Flug /
Sul volo degli uccelli*, deutsch/italienisch, hg. und übersetzt von
Marianne Schneider, München 2000.
3 Vgl. vor allem Samuel Becketts spätes Prosawerk
Aufs Schlimmste zu, in: ders., *Worstward Ho / Aufs Schlimmste zu*
(1983), Frankfurt am Main 1989, S. 7.
4 Der englische Begriff »Camp« wanderte über Susan Sontag in
den deutschsprachigen Raum. Er fand keine adäquate Überset-
zung. Sontag bezeichnet dieses »postdandyistische« Phänomen als
eine Liebe zum Unnatürlichen, als eine Erlebnisweise, die das
Scheitern der Ernsthaftigkeit feiert, die sich gern an der Oberfläche
aufhält, die Nachahmung und Travestie als Formen schätzt. Vgl.
Sontag, *Anmerkungen zu »Camp«*, in: dies., *Kunst und Antikunst.
24 literarische Analysen*, Reinbek bei Hamburg 1968, S. 269–284.
5 Ebd., S. 273.
6 Vgl. Judith Butler, *Das Unbehagen der Geschlechter* (1990),
Frankfurt am Main 2003.
7 Die berühmten Sätze »Je est un autre« und »C'est faux de
dire: je pense. On devrait dire: on me pense« erschienen in
Rimbauds *Voyant*-Briefen, vgl. Arthur Rimbaud, *Briefe und Doku-
mente*, hg. und übersetzt von Curt Ochwadt, Heidelberg 1961,
S. 24.

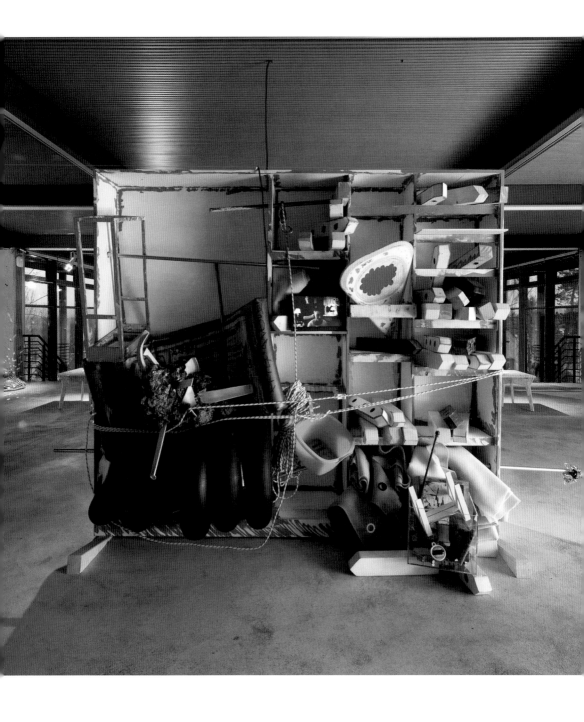

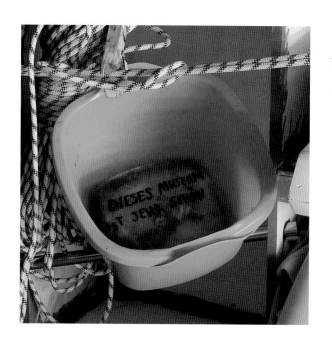

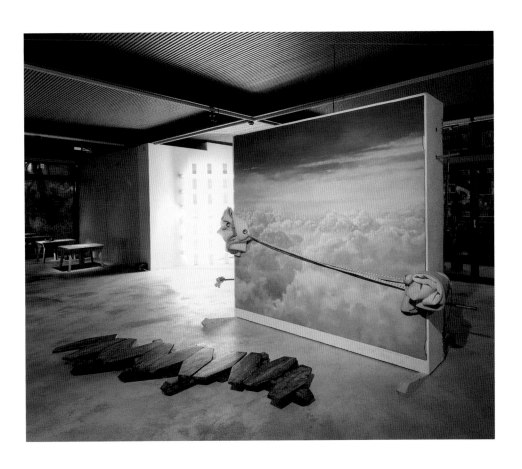

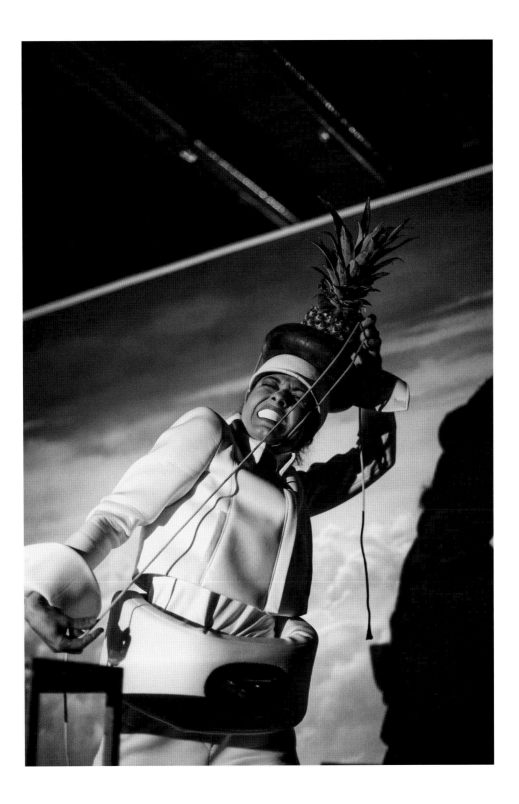

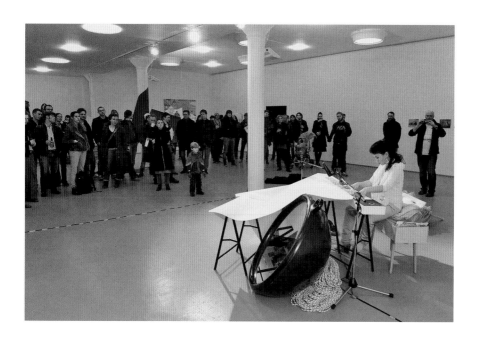

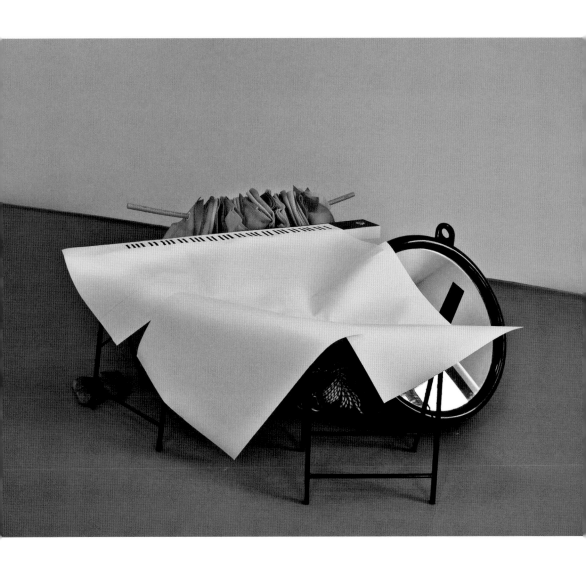

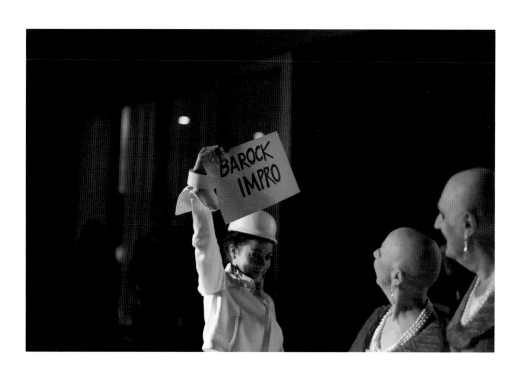

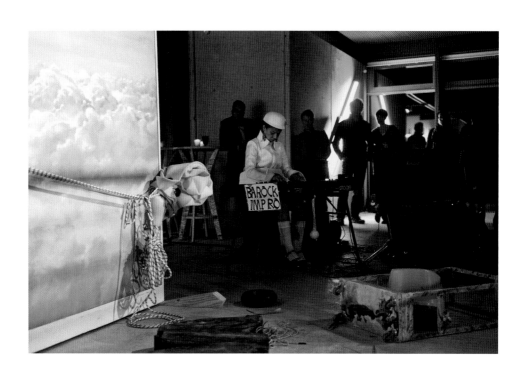

PICTURES ABBILDUNGEN

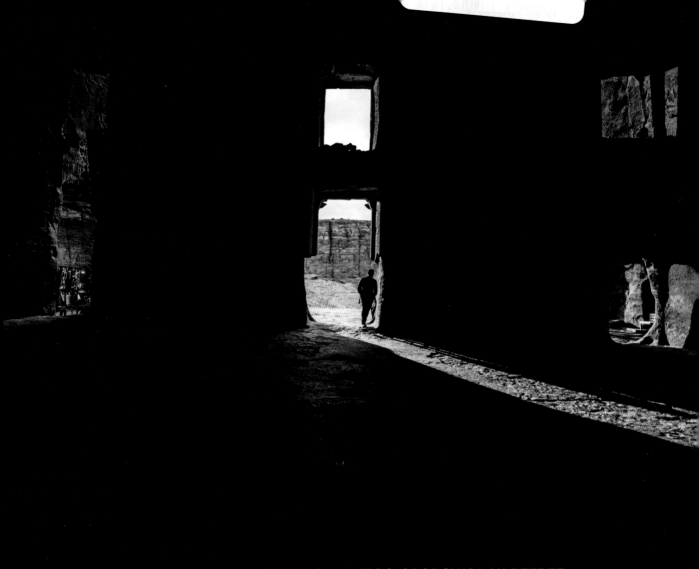

WNĘTRZE SKALNEGO GROBOWCA W PETRZE

INTERIOR OF THE ROCK TOMB IN PETRA

PORANEK...

MORNING...

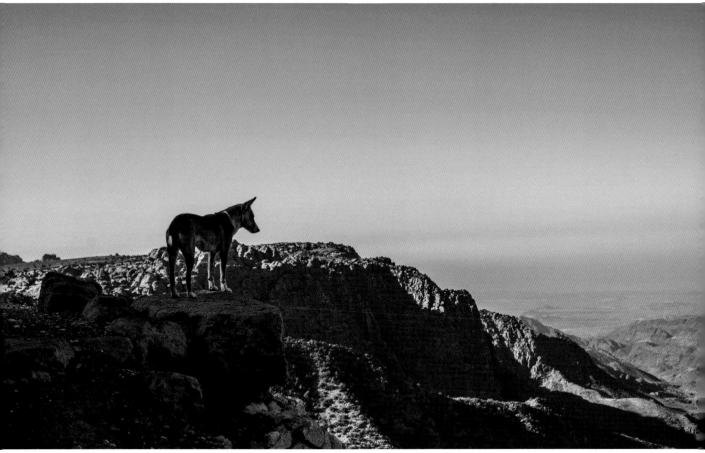

RUINY ŚWIĄTYNI HERKULESA W AMMANIE

RUINS OF THE TEMPLE OF HERCULES IN AMMAN

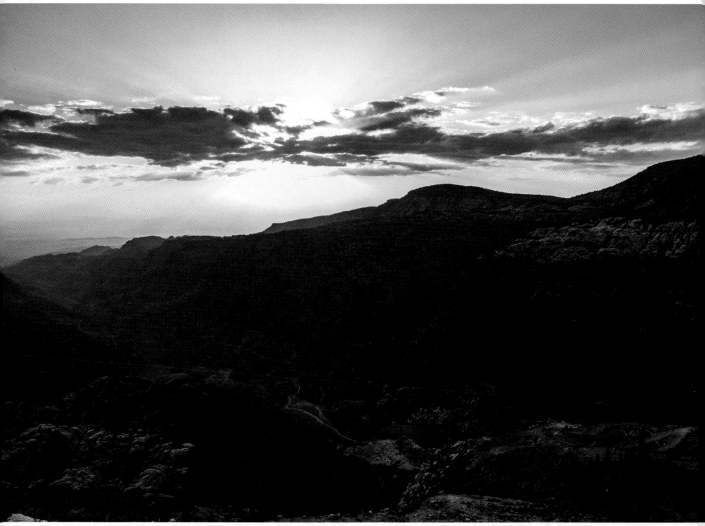

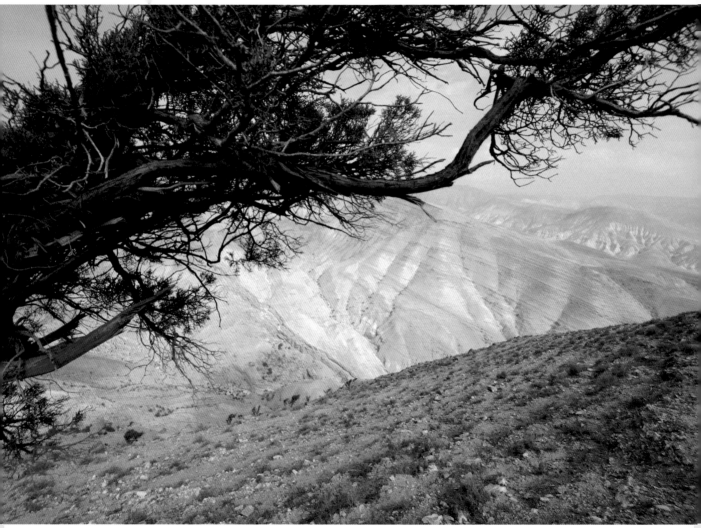

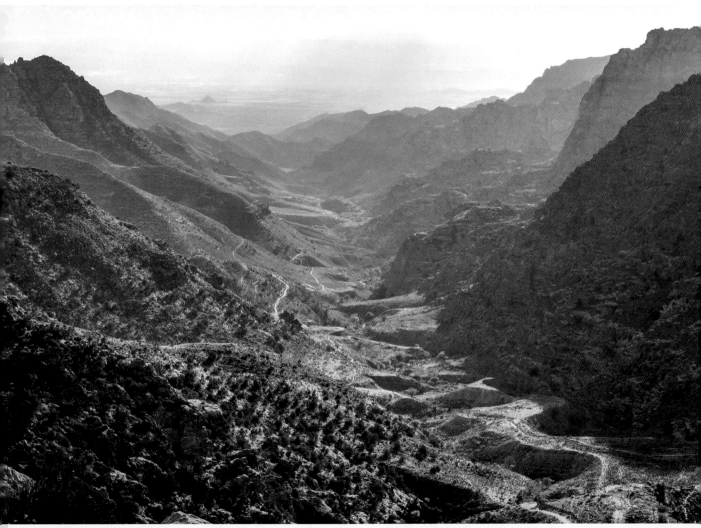

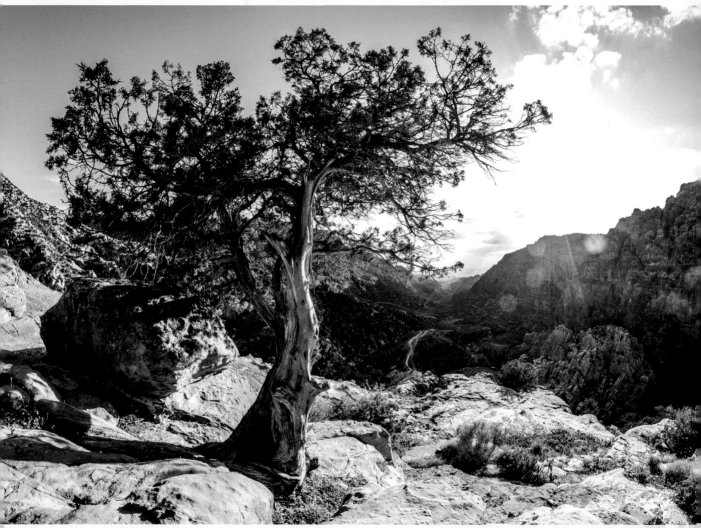

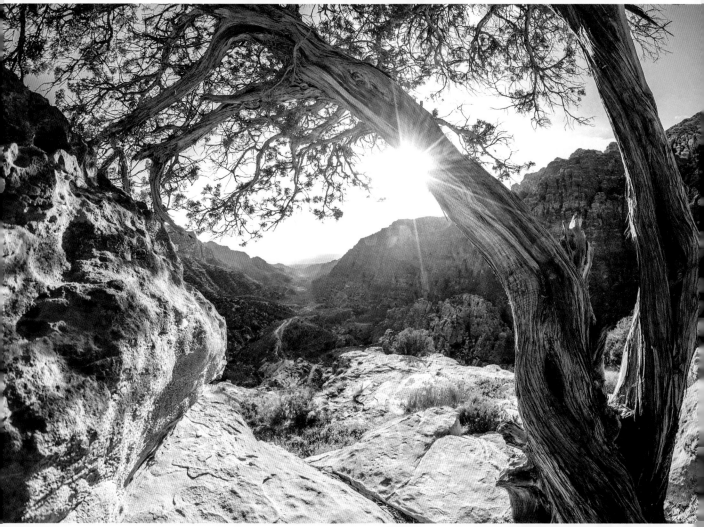

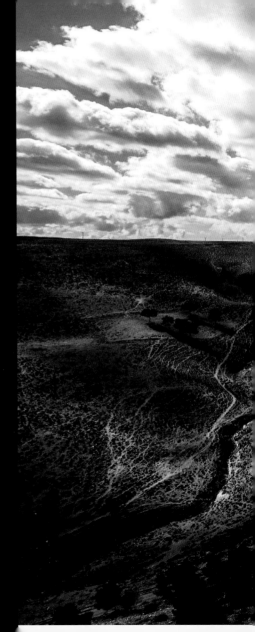

EDOM · ODKRYWANIE

Są miejsca na Ziemi, które są naprawdę wyjątkowe – tak nasycone śladami przeszłości, że niemal rozbrzmiewają głosami ludzi, którzy żyli tam przed wiekami. Spacerując po bezdrożach południowej Jordanii lub odwiedzając pustynne stanowiska archeologiczne w tej części kraju, spotykamy się nie tylko z zabytkami lub informacjami o życiu dawnych wspólnot, ale także z dzisiejszymi problemami ich ochrony, konserwacji często skomplikowanym funkcjonowaniem we współczesnym świecie. Będąc skarbnicą wiedzy

EDOM · DISCOVERING

There are places on Earth that are truly unique – so saturated with the traces of the past that they almost echo with the voices of people who lived there centuries ago. Strolling through the wilderness of southern Jordan or visiting desert archaeological sites in this part of the country, we discover not only monuments or information about the life of past communities, but also today's problems of their protection, conservation and often complicated functioning in the modern world. Being a treasury of knowledge about our past, southern

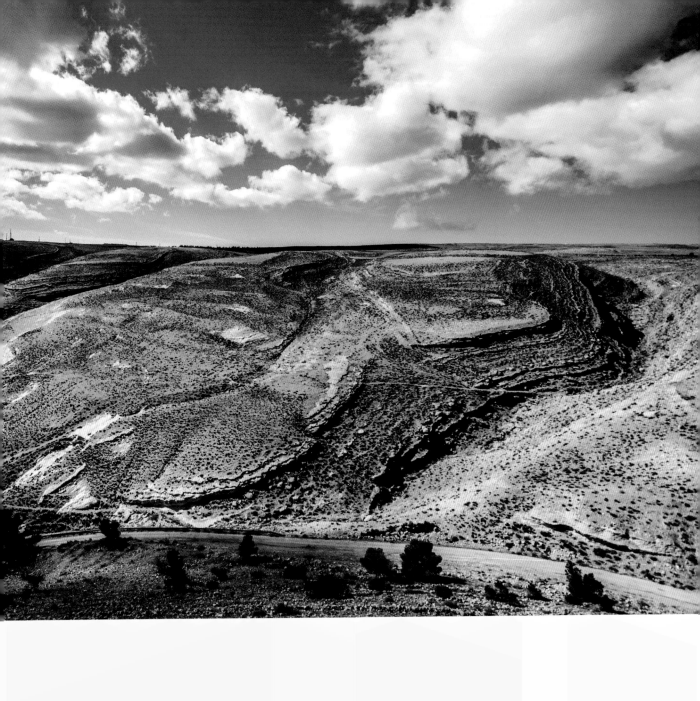

o naszej przeszłości, południowa Jordania – historyczna kraina Edom – powinna być nieustannym polem aktywności naukowej, która może przynieść nie tylko nowe zabytki czy ślady przeszłości, ale także ogromną ilość informacji pozwalających na poszerzenie naszej wiedzy o dawnych czasach.

Przywilejem archeologa jest nie tylko badanie przeszłości i obcowanie z zabytkami, ale także spotkanie z pięknem tego regionu oraz doświadczanie życzliwości i gościnności ludzi, którzy żyją w tym niezwykłym miejscu.

W 2014 roku na terenie południowej Jordanii rozpoczął się cykl nowych, polskich projektów badawczych. Archeolodzy i studenci z Uniwersytetu Jagiellońskiego w Krakowie prowadzą w jego ramach badania powierzchniowe i wykopaliska na terenie dystryktów Tafila i Shawbak. Projektami kieruje grupa naukowców z Instytutu Archeologii Uniwersytetu Jagiellońskiego. We współpracy z jordańskim Departamentem Starożytności polscy badacze poszukują śladów ludzkiej aktywności na tym obszarze od epoki kamienia do okresu średniowiecza. Obszar poszukiwań i badań jest

PRACA NAD ZABYTKAMI KRZEMIENNYMI I CERAMICZNYMI POZYSKANYMI W TRAKCIE BADAŃ

WORK ON FLINT AND CERAMIC MONUMENTS ACQUIRED DURING THE RESEARCH

be a constant field of scientific activity that can offer not only new monuments or traces of the past, but also a huge amount of information that allows us to expand our knowledge about old times. The archaeologist's privilege is not only to study the past and come into contact with monuments, but also to rejoice in the beauty of this region and to experience the friendliness and hospitality of people who live in this unique place.

In 2014, a series of new Polish research projects began in southern Jordan. Archaeologists and students from the Jagiellonian University in Kraków conduct surface research and excavations within the districts of Tafila and Shawbak. The projects are directed by a group of scientists from the Institute of Archaeology of the Jagiellonian University. In cooperation with the Jordanian Department of Antiquity, Polish researchers are looking for traces of human activity in this area, dating from the Stone Age to the Middle Ages. The area of exploration and research is located in the vicinity of important archaeological sites such as the capital of the Buseira edomites or the Sela

PRACE WYKOPALISKOWE NA STANOWISKU AIN SAWAN

EXCAVATIONS AT AIN SAWAN

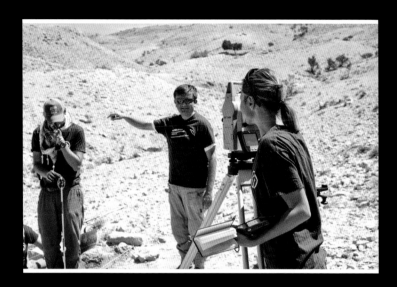

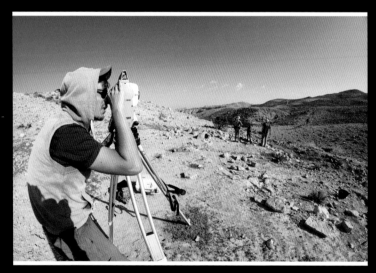

położony w sąsiedztwie ważnych stanowisk archeologicznych, takich jak stolica państwa edomitów Buseira czy skalne refugium Sela, a także nieopodal Wadi Feynan – słynnej doliny miedzi, która odgrywała kluczową rolę w produkcji tego surowca i jego eksporcie na sąsiednie tereny, szczególnie w epoce brązu. To w tej części Jordanii znajduje się także jej najsłynniejszy zabytek – Petra, czyli skalne miasto nabatejczyków, oraz zamek krzyżowców w Shawbak.

Najdłużej trwającą aktywnością badawczą krakowskich archeologów jest projekt poświęcony w sposób szczególny epoce brązu. Znaleziska z tego okresu mogą pomóc w uzyskaniu odpowiedzi na pytania o obecność i aktywność grup ludzkich na terenie Edomu w tym czasie. Długoterminowym celem badań jest poszukiwanie i analizowanie szlaków oraz dróg przemieszczania się ludzi w okresach pradziejowych na tym terenie, a także rejestracja zmian środowiska i ich wpływu na funkcjonowanie ówczesnych społeczności. Całość podejmowanych w ramach projektu działań i badań jest początkiem szerokich prac nakierowanych na

rock cliff, and also near Wadi Feynan – the famous copper valley, which played a key role in the production of this raw material and its export to neighboring areas, especially in the Bronze Age. In this part of Jordan there is also its most famous monument – Petra, or the rock city of the Nabataeans, and the crusader castle in Shawbak.

The longest-lasting research activity of Kraków archaeologists is a project devoted in a special way to the period of the Bronze Age. Findings from this period can help answer questions about the presence and activity of human groups during this period in Edom. The long-term goal of the research is to search for and analyze the routes and paths of people moving in prehistoric periods in this area, as well as environmental changes and their impact on the functioning of past societies. The whole of the activities and research undertaken as part of the project is the beginning of a broad work aimed at getting to know the region and describing its cultural landscape and the role of the environment and its changes

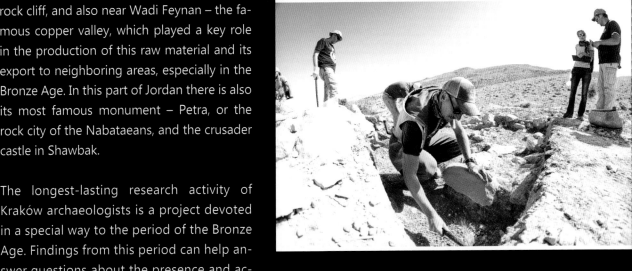

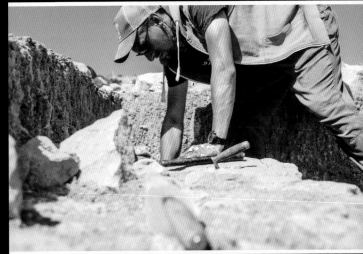

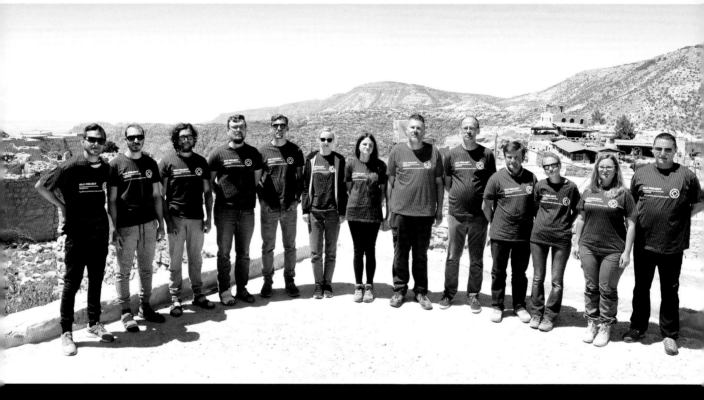

EKIPA PROJEKTU HLC W SEZONIE 2019

THE HLC TEAM IN THE 2019 SEASON

SKARBIEC EL·KHAZNEH, CZYLI GROBOWIEC ARETASA IV W PETRZE

EL·KHAZNEH TREASURY OR THE TOMB OF ARETAS IV IN PETRA

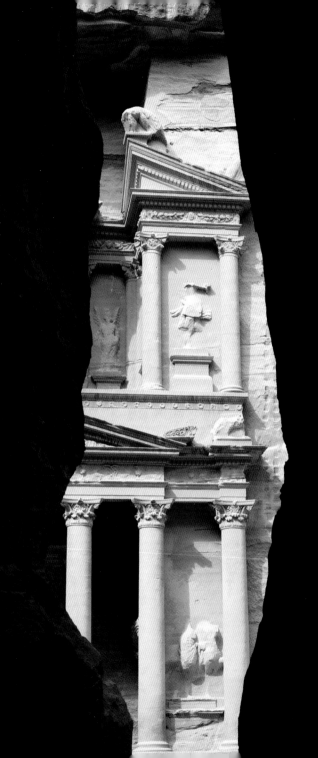

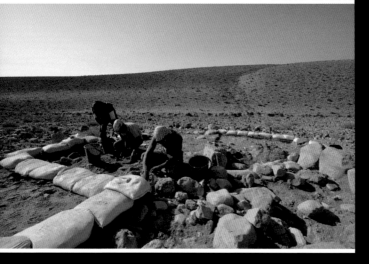

wskazanie atrakcji turystycznych i zwrócenie
uwagi na wartości kulturowe i środowiskowe
warte ochrony i upowszechniania.

Prace prowadzone przez polskich naukow-
ców na terenie południowej Jordanii odby-
wają się w trudnym, pustynnym i górskim
rejonie. Jak dotąd udało się zidentyfikować
i opisać około 100 stref, w obrębie których
występują zabytki archeologiczne, które
podlegają obecnie dalszym analizom. Pozy-
skano także tysiące zabytków ceramicznych
i krzemiennych, a także wiele innych przed-
miotów datowanych na różne okresy.

PRACE WYKOPALISKOWE NA STANOWISKU
FAYSALYYIA

EXCAVATIONS AT THE FAYSALYYIA SITE

Krakowskie prace badawcze prowadzone na
terenie Jordanii od 2014 roku to pierwsze
samodzielne działania naukowe polskich ar-

cientists understand the region's functioning across centuries, but also aid its development by identifying tourist attractions and drawing attention to cultural and environmental values worth protecting and popularizing.

The work carried out by Polish scientists in southern Jordan takes place in a difficult, desert and mountainous region. So far, about 100 zones have been identified and described, including archaeological relics, which are currently undergoing further analysis. Thousands of ceramic and flint relics were also acquired, as well as many other objects dated to various periods.

It is also worth mentioning that the Kraków research works conducted in Jordan since 2014 are the first independent scientific activities of Polish archaeologists in this area. Their start was also possible thanks to the support of Italian archaeologists who have been working in Jordan for over 30 years. The Italian team, headed by Professor Guido Vannini from the University of Florence,

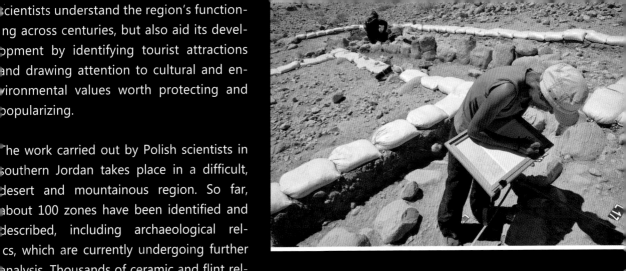

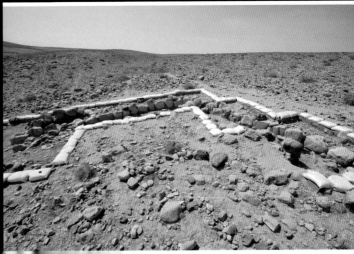

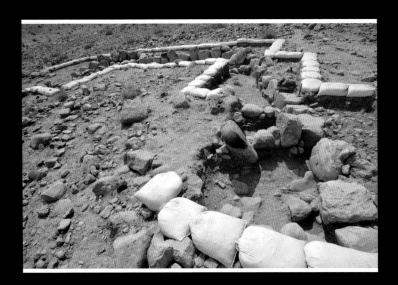

ponad 30 lat. Włoski zespół, kierowany przez profesora Guido Vanniniego z Uniwersytetu we Florencji, udostępnił polskim naukowcom bazę i wspomógł doświadczeniem na początkowym etapie projektu.

Prace krakowskich badaczy w Jordanii zostały zauważone przez Narodowe Centrum Nauki, które przyznało grant na ich rozszerzenie w celu głębszego poznania dziejów południowej Jordanii w epoce brązu. Rozpoznanie tego okresu na terenie Jordanii stanowi jeden z najciekawszych problemów badawczych współczesnej archeologii Bliskiego Wschodu. Ten okres, trwający ok. 1750 lat (3700–1950 p.n.e.), obfitował w wydarzenia i zmiany kluczowe dla rozwoju cywilizacji. Wówczas powstały pierwsze ośrodki o charakterze miejskim, rozwijała się technologia produkcji wielu przedmiotów (np. metalurgia), następował rozkwit dalekosiężnego handlu. Na obszarze Egiptu i Bliskiego Wschodu zaszły w tym czasie ważne zmiany społeczne – powstały pierwsze królestwa o charakterze przestrzennym (Egipt w okresie predynastycznym, archaicznym i Starego Państwa) oraz miasta-państwa (Mezopota-

and shared their experience at the initial stage of the project.

The works of Kraków researchers in Jordan have been recognized by the National Science Center, which provided a grant to expand them in order to learn more about the history of southern Jordan in the Bronze Age, the exploration of which is one of the most interesting research problems of contemporary archeology in the Middle East. This period, which lasted approximately 1750 years (3700–1950 BC), was full of events and changes crucial for the development of human culture. The first centers of urban character were created, the technology of production of many objects developed (e.g. metallurgy) and the long-distance trade flourished. In the area of Egypt and the Middle East there were many important social changes in this period – the birth of first kingdoms of a spatial nature (Egypt in the predynastic, archaic and Old State periods) and the city-states (Mesopotamia, Syria-Palestine) controlling minor areas; the shaping and gradual deepening

**NARADA W BAZIE ARCHEOLOGÓW
· REZERWAT DANA**

**MEETING
AT THE ARCHAEOLOGISTS' HEADQUARTER
· DANA NATURE RESERVE**

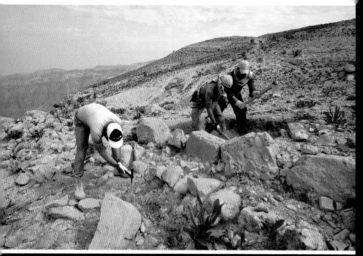

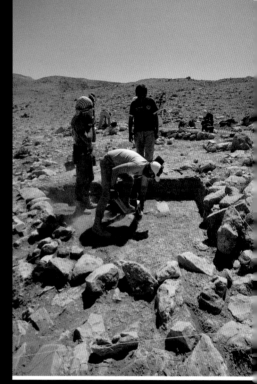

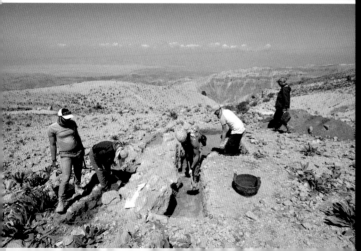

**PRACE BADAWCZE
NA STANOWISKU
AIN SAWAN NORTH**

RESEARCH WOR

...nia, Syro-Palestyna) sprawujące kontrolę nad mniejszymi obszarami. W tym czasie kształtowała się i stopniowo pogłębiała hierarchiczna, skomplikowana struktura społeczności, rozwijały się kulty i zwyczaje pogrzebowe. Poawiło się pismo oraz rozbudowana ideologia władzy i religii. Widoczne są przesunięcia ludności i wpływ mobilnych grup koczowniczych na funkcjonowanie szczególnie obszaru południowej Jordanii, który w otoczeniu dynamicznie zmieniających się terenów nie mógł być „białą plamą".

Niestety, stan badań nad problematyką wczesnej epoki brązu na obszarach Lewantu nie jest jednolity, stąd celem projektu jest próba ustalenia roli południowej Jordanii w tym ważnym okresie. Poprzez wykopaliska archeologiczne na wyselekcjonowanych stanowiskach badacze z Krakowa starają się opisać etapy aktywności człowieka. Celem analiz jest także odpowiedź na pytanie o ewentualne kontakty tego regionu z Egiptem i resztą Lewantu, czyli obszarami, na których w epoce brązu zachodzą ważne zmiany, a stan badań nad tym okresem jest tam bardziej zaawansowany. Prace wykopaliskowe uzupełniane

of the hierarchical, complicated structure of the communities; the development of cults and funerary customs. Writing appeared for the first time as well as developed ideology of power and religion. There were visible population shifts and the impact of mobile nomadic groups was visible, especially in the southern Jordan area, which could not remain a "white spot" in the vicinity of dynamically changing areas.

Unfortunately, the research on the issues of the early Bronze Age is not uniform in the Levant territories; therefore, the goal of our project is to try to determine the role of the southern Jordan region in this important period. Through archaeological excavations on selected sites, researchers from Kraków are trying to describe the stages of past human activity. The aim of the analyzes is also to answer the question about possible contacts of this region with Egypt and the rest of the Levant, i.e. areas where important changes took place at that time, and where the state of research on the Bronze Age is more advanced. Excavation works are supplemented with specialized laboratory analyzes, thanks

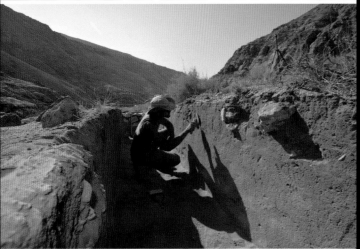

są specjalistycznymi analizami laboratoryjnymi, dzięki którym poznajemy dokładny wiek odkrywanych zabytków, a także sposoby ich produkcji i użytkowania.

Prace polskich projektów badawczych stanowią także ważny przyczynek do ochrony zabytków i stanowisk archeologicznych na tym terenie, często niedocenianych ze względu na swój stosunkowo mało spektakularny charakter, lecz kluczowych dla rozwoju wiedzy naukowej. Badania pozwolą na zebranie materiału umożliwiającego rozwinięcie prac polskich naukowców na terenie Jordanii w kolejnych latach.

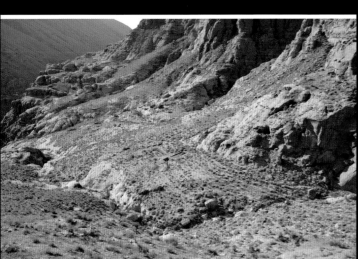

BADANIA WYKOPALISKOWE NA STANOWISKU MUNQATA'A

EXCAVATIONS AT MUNQATA'A SITE

to which it is possible to establish the exact age of discovered relics, as well as the ways of their production and use.

The work of Polish research projects is also an important contribution to the protection of archaeological heritage in this area, often underestimated today due to its relatively less spectacular character, but crucial for the development of scientific knowledge. The research also allows the collection of material that will render the development of the work of Polish scientists in Jordan in the following years possible.

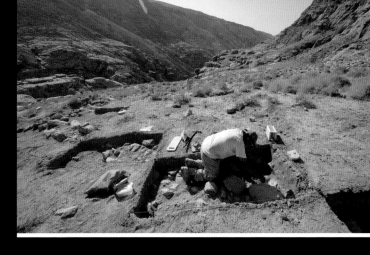

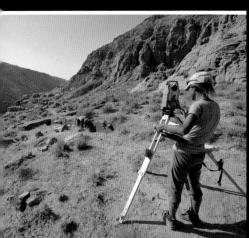

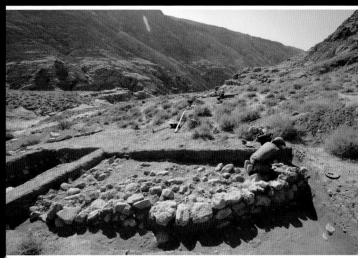

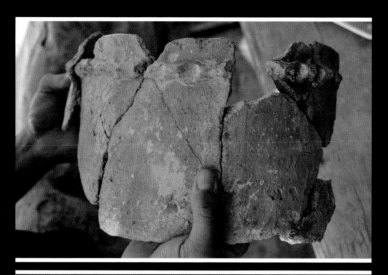

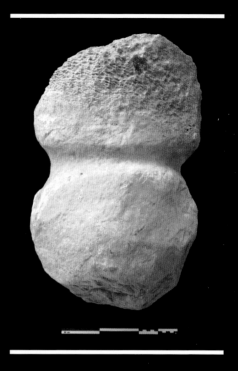

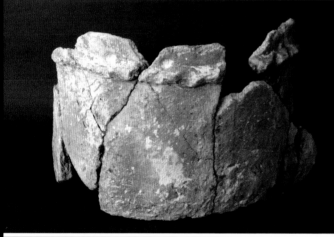

**KAMIEŃ NAMIOTOWY
Z WCZESNEJ EPOKI BRĄZU
· FAYSALYYIA**

**TENT STONE FROM THE EARLY
BRONZE AGE
· FAYSALYYIA**

**CERAMICZNA MISA DATOWANA NA OKRES WCZESNEJ
EPOKI BRĄZU · FAYSALYYIA**

**CERAMIC BOWL DATED TO THE PERIOD OF THE EARLY
BRONZE AGE · FAYSALYYIA**

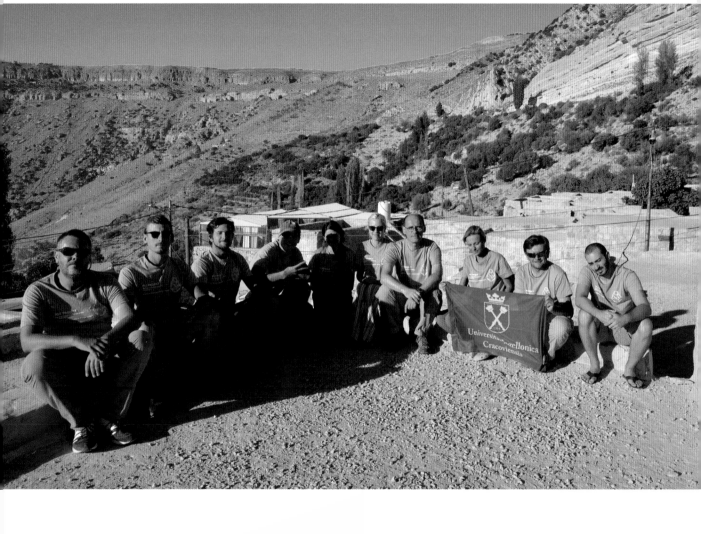

POLSKIE PROJEKTY BADAWCZE W POŁUDNIOWEJ JORDANII

POLISH RESEARCH PROJECTS IN SOUTHERN JORDAN

Heritage|Landscape|Community Project · (HLC Project)

Badania poświęcone wczesnej epoce brązu w kontekście zmian środowiskowych i tradycji epok wcześniejszych.

Kierownik projektu: dr Piotr Kołodziejczyk

Heritage|Landscape|Community Project · (HLC Project)

Research dedicated to the early Bronze Age in the context of environmental changes and traditions of earlier eras.

Project leader: Dr. Piotr Kołodziejczyk

ARTU-DTU · Badania archeologiczne na stanowiskach Dajaniya i Tuwaneh

Badania poświęcone okresowi rzymskiemu i osadnictwu późnoantycznemu w południowej Jordanii.

Kierownicy projektu: dr hab. Jarosław Bodzek, dr Kamil Kopij, mgr Łukasz Miszk

ARTU-DTU · Archaeological research at Dajaniya and Tuwaneh sites

Research devoted to the Roman period and late Romanesque settlement in southern Jordan

Project leaders: Prof. Jarosław Bodzek, Dr. Kamil Kopij, Łukasz Miszk, MA

Średniowieczne zamki południowej Jordanii · Qasr ed Deir

Badania średniowiecznego założenia militarno-klasztornego w rejonie Tafili.

Kierownicy projektu: dr Przemysław Nocuń, mgr Agnieszka Ochał-Czarnowicz

Medieval castles of southern Jordan · Qasr ed Deir

Research on the medieval military-monastic foundation in the region of Tafila.

Project leaders: Dr. Przemysław Nocuń, Agnieszka Ochał-Czarnowicz, MA

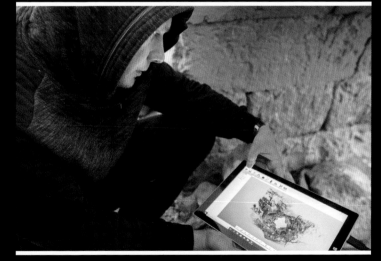

**PRACE BADAWCZE NA
STANOWISKU DAJANIYA**

**RESEARCH WORKS
IN THE DAJANIYA ROMAN
FORT**

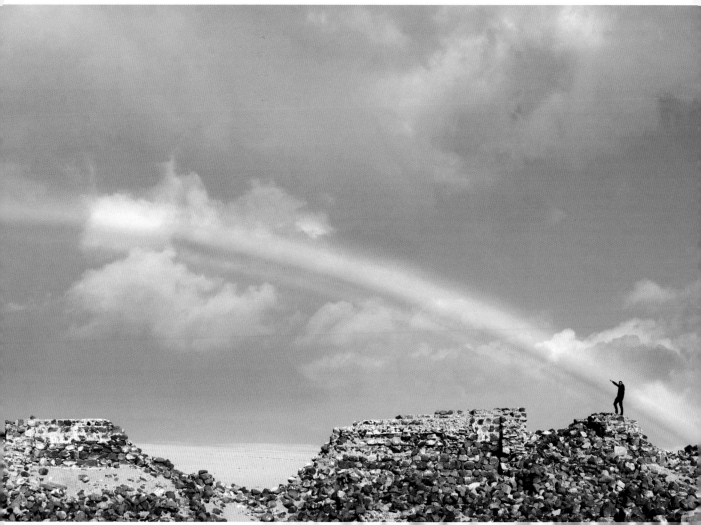

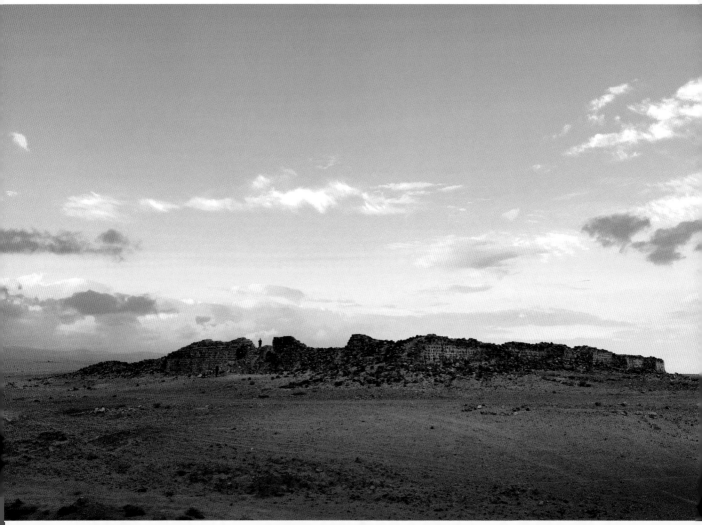

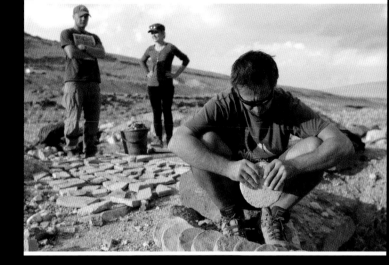

**PRACE BADAWCZE
I DOKUMENTACYJNE
NA STANOWISKU TUWANEH**

**RESEARCH AND DOCUMENTATION
WORK AT TUWANEH**

Jordania – czyli zgodnie z oficjalną nazwą Jordańskie Królestwo Haszymidzkie – to kraj położony na Bliskim Wschodzie, w Azji Południowo-Zachodniej. Warszawa i Amman, czyli stolica Jordanii, oddalone są od siebie o około 3500 km. Jest to państwo o powierzchni około 89 tys. km².

Królestwo Jordanii graniczy z Izraelem (238 km), Autonomią Palestyńską (97 km), Syrią (375 km), Irakiem (181 km) i Arabią Saudyjską (744 km). Łączna długość granic wynosi 1635 km. Jordania posiada także niewielki dostęp do morza w rejonie Zatoki Akaba (Morze Czerwone), a długość wybrzeża wynosi jedynie 26 km.

Jordania jest monarchią konstytucyjną, a obecnie panującym władcą jest król Abdullah II, syn króla Husajna, potomek dynastii Haszymidów. Haszymidzi to arystokratyczny ród arabski z plemienia Kurajszytów, wywodzący się od potomków dziadka Mahometa, Haszima ibn Abd al-Manafa.

Jordan – that is, according to the official name, the Hashemite Kingdom of Jordan - it is a country located in the Middle East, in South-West Asia. Warsaw and Amman, or the capital of Jordan, are about 3,500 km apart. It is a country with an area of about 89 thousand km².

The Jordanian Kingdom borders on Israel (238 km), the Palestinian Autonomy (97 km), Syria (375 km), Iraq (181 km) and Saudi Arabia (744 km). The total length of the borders is 1635 km. Jordan also has limited access to the sea in the Gulf of Aqaba (Red Sea), with the length of the coast being only 26 km.

Jordan is a constitutional monarchy, and the current ruler is the king Abdullah II, son of King Hussein, descendant of the Hashemite dynasty. The Hashemites are an aristocratic Arabian tribe from the Qurayc tribe, descended from the descendants of grandfather of the Muhammad, Hashim ibn Abd al-Manaf.

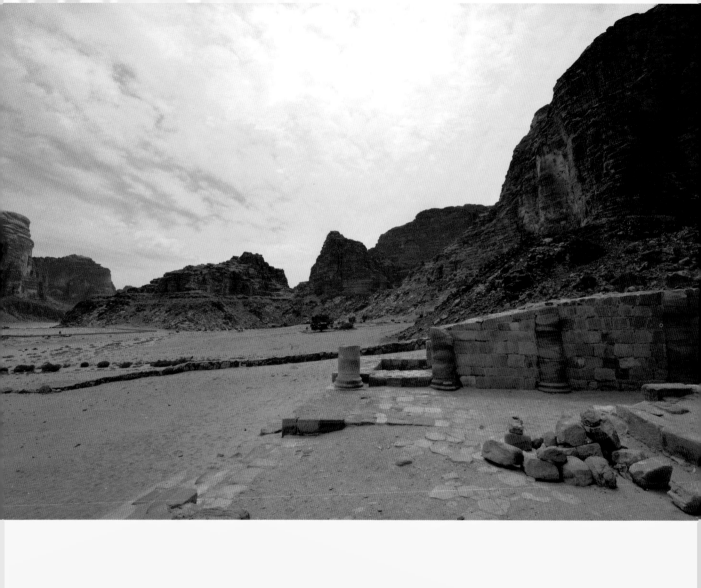

...PUSTYNI · WADI RUM

...OF THE DESERT · WADI RUM

Południowa Jordania to obszar położony pomiędzy Wadi Hasa a Zatoką Akaba, czyli historyczna kraina zwana Edomem. Jest to teren podzielony południkowo na tereny skalisto-górzyste zlokalizowane po jego zachodniej stronie i pustynno-wyżynne leżące po jego stronie wschodniej. Na zachodzie granice wyznacza także ryftowa dolina Jordanu, czyli najbardziej na północ wysunięta część Rowu Abisyńskiego, który należy do Wielkich Rowów Afrykańskich. Tereny na wschodzie regionu przechodzą w rozległe pustynie Półwyspu Arabskiego – największego półwyspu świata.

Przez te obszary przebiega jeden z najbardziej znanych szlaków handlowych i pielgrzymkowych starożytności i średniowiecza czyli tzw. Droga Królewska. To tam znajdują się relikty wschodniej granicy Imperium Romanum – *Limes Arabicus* oraz zbudowanej dla poprawienia kontaktów handlowych rzymskiej drogi cesarza Trajana – *Via Nova Traiana*. To właśnie tutaj znajdują się najbardziej znane zabytki, kojarzone na całym świecie – czerwone skały i grobowce Petry – oraz niezwykłe krajobrazy Wadi Rum, które odgrywały rolę Marsa w wielu hollywoodzkich produkcjach filmowych.

Southern Jordan is the area between Wadi Hasa and the Gulf of Aqaba, or the historical land called Edom. It is a meridian-divided area – rocky-mountainous areas located on its western side and desert-highlands lying on the eastern side. In the west the boundary is also marked by the rift of the Jordan River, which is the northernmost part of the Abyssinian Trench, which belongs to the Great African Trenches. Areas in the east of the region pass into the vast deserts of the Arabian Peninsula – the largest peninsula in the world.

Through the area of southern Jordan runs one of the most famous trade and pilgrimage routes of antiquity and the Middle Ages, i.e. King's Road. There are also relics of the eastern border of the Roman Empire – *Limes Arabicus* and the Roman road built by Emperor Trajan – *Via Nova Traiana*. It is southern Jordan where the most famous monuments associated throughout the world with Jordan can be found – the red rocks and tombs of Petra – and the extraordinary landscapes of Wadi Rum, which played the role of Mars in many Hollywood film productions.

Warto jednak wiedzieć, że południowa Jordania ma nam do zaoferowania znacznie więcej! Znajdziemy tu dziesiątki miejsc naznaczonych ludzką obecnością od czasów najdawniejszych po czasy współczesne. Znajdują się tutaj stanowiska archeologiczne z okresu paleolitu, neolitu, epok brązu i żelaza, a także niezliczona ilość reliktów działalności Nabatejczyków i Rzymian. Nie da się także nie zauważyć niezwykłego dziedzictwa średniowiecza ze wspaniałym zamkiem w Shawbak na czele i twierdzami krzyżowców w Al-Habis i Al-Wueira oraz wieloma bizantyjskimi miastami i budowlami rozsianymi po całym obszarze południowej Jordanii.

To właśnie ten bogaty krajobraz kulturowy południowej Jordanii przyciągnął polskich archeologów, przyrodników i popularyzatorów nauki i stał się miejscem ich pracy. Od kilku lat naukowcy prowadzą tutaj badania wykopaliskowe i środowiskowe, poszerzając naszą wiedzę na temat historii i przyrody regionu.

It is worth knowing, however, that the southern Jordan has much more to offer! We will find here dozens of places marked by human presence from the earliest times to modern times. There are archaeological sites from the Paleolithic, Neolithic, Bronze and Iron ages, as well as countless relics of the Nabateans and Romans. It is also impossible not to notice the extraordinary heritage of the Middle Ages with the magnificent Shawbak Castle and the crusader strongholds in Al-Habis and Al-Wueira, as well as many Byzantine cities and buildings scattered all over Southern Jordan.

It was this rich cultural landscape of southern Jordan that attracted Polish archaeologists, naturalists and popularizers of science and became the place of their work. For several years, scientists have been carrying out excavation and environmental research here, expanding our knowledge about the history and nature of the region.

هناك مكانن امام فريده من نوع اها حق على أقى كوكب الأرض ـ تعج بآثار المضي للدرجة انها تقريرا بُردّ صدى
من هزهة ربع الطبيعة جنوبي الأردن او عند زيارة المواقع الأثرية في قرون. منذ قرون كان هناك اوشاع من الص
الصحراوية في هذا الجزء من الأردن، لا نكنتشف آثار او المعلومات حول حياة المجتمعات المحلية حفسب
 بل، نكنتشف أيضا مشاكل لكل عصر انرصها المعتلقة بحفظ المامهتم والحفاظ عليهم ودورهم في مواقع المعلم انا المعاصر
في كثير من الأحيان نكنن انزا كزلل للمعرفة حول مضاينا، يجب أن نكون جنوب الأردن ـ أرضا إدوم التاريخية
ميدانا دائما للنشاط العلمي لا نكمن أن يقدم فقط آثارا أو معالم جديدة من المضي حفسب، ولكن
أيضا قدرا كبير من المعلومات التي حتى تتيح لنا انن زيادة معرفتنا بالأزمنة القديمة. لا يقتصر عالم
والتعامل والتواصل مع المعالم الأثرية حفسب، بل أيضا بالاجتهاب بجهام هذه المنطقة
والتعامل بدون مركز وكوب مضاينا من مضايفة في يعيشون هذا المكان الفريد.

في عام 2014، تأبدأ سلسلة من المشاريع البحثية البولندية الجديدة جنوب الأردن. حيث قام علماء
الآثار والطلاب من جامعة غياغليونيان باجراء أبحاث مسحية وحفر داخل مقاطعتي الطفيلة والشوبك.
تُحادث هذه المشاريع من قبل مجموعة من علماء الآثار من معهد جامعة غياغليونيان. بالتعاون مع دائرة
الآثار العامة الأردنية، يبحث الباحثون البولنديون عن آثار النشاط البشري في هذا المجال، والتي
يعود تاريخها الى العصر الحجري وحتى العصر الوسطى. تقع منطقة الاستكشاف والبحث بالقرب
من المواقع الأثرية الهامة مثل عاصمة البوسيرية أو edomites ـ فرج صخرة Sela، وكذلك بالقرب من وادي
في نانان ـ وادي النحاس الشهير، ر، والتي تلعب دورا ارا رئيسيا في الانتاج من هذه المواد الخام وتصديرها الى
المنطقة المجاورة، وخاصة في العصر البرونزي. يوجد في هذا الجزء من الأردن أكثر المعالم الأثرية العالمية شهرة
وهو ـ البترا، أو مدينة الأنباط الصخرية، والقلعة الصليبية في شوباكا

يعد النشاط البحثي للعلماء في الآثار كاركاكف مشروعا رائعا مخصصا طب ريقتميز تتز لفترة العصر
البرونزي. يمكن. حساعد هذه الاجابة على لئ سؤال حول وجود ونشاط
المجموعات البشرية خلال هذه الفترة. موما. الهدف الطويل المدى من البحث هو ثحث عن طرق مسارات
الأشخاص الذين ينتقلون في تاريخ هذا المجال والتحليها، لبعد ما تفترات في الاغتيرارات الى الإضافة الى التغيرات

البيئية وتأثيرها على عمل أفراد.ان كل الأنشطة والأبحاث التي تم إجراؤها هي جزء من المشروع هي بداية
عمل ولها تحولات اهتماتي تغيرية وتؤدي رودو البيئية ومصفف المشهد الثقافي ودودو المنطقة على فرع التعرف على إلى فهدي وعسا ويهدي في
سوف يساعد أيضا في معرفة اذه المشروع ورود دور على فهم العلماء المنطقة على مدار قرون، ولكنه يمكنه أيضا يساعد في
ةرة الجديدة البيئية الثقافية والقيم ونحو ر الأنظار تفلت القيم والفلوي السياحي بذب الجذب قطان تحديد من خلال اهروطوت
بالحماية والترويج لها.

من الجديد ركز الذلك أيضا أن أعمال ك كاكراف وكاكراف البحثية التي تُرىجِجَت في الأردن منذ عام 2014 هي أول أنشطة
عملية مستقلة لعلماء الآثار بولنديين في هذه المنطقة. بدايتها اهتمانت كانت ممكنة أيضا بفضل دعم علماء الآثار
رو سيروف البروفيسر برئاسة الإيطالي، ي الإيطالي ق فرفر الفريق قام عام 30 من أكثر منذ الأردن في يعملون الذين الإيطاليين
غيدودو غ من جماعة من روسيون واس، وتبفير ربفير القاعدة للعلماء البولنديين لتبادل الخبرات في المرحلة
الأولية من المشروع.

تم الاعتراف بأعمال باحثي ك كاكراف في الأردن من قبل ال ال ز المركز الوطني للعلوم، الذي قدم منحة لتوسيع ماها اهوعا تم
أجل معرفة المزيد عن خيرات خونج البوب الأردن في العصر البرونزي، الذي يعيد استكشاف ههف في الشرق الأوسط
أحد المشاكل للكلك البحثية الأكثر إثارة قرارة في ملع ماما للاهتمام في الآثار المعاصر. كانت هذه الفترة، التي استمرت
حوالي 1750 سنة (3700-1950 قبل الميلاد)، وتيلى بالأحداث الحاسمة لتنمية الثقافية
الإنسانية.أنشئت أول ذات كراك عباطا حضري ازدهرت تقنية إنتاج العديد من الأشياء (مثل المعادن)
هناك كان العديد من تغيرات الاجتماعية المهمة في تلك الفترة أنشأة - المماللكا الأولى ذات الطبيعة المكانية
(مصر في فترة ما قبل الأسرات والفترة القديمة والدولة القديمة) ودودو المدن ما دالب بين النهرين
لتكلشت تغيري صغيرة على طرق على السيطرة قيمة وتعميق التدريجي للهيكلي الرمزي والمعقد سوروري - ايريرو
للمجتمعات الفردية ؛ وتطور وأي ولوجيادي الطبيعة والعادات الجنائزية رهظت. الكتابات لأول مرة وأي تطور
في ايكيايا ديناميكية تغيرة المناطق المتنقلة ؛ هناك كان تحولات سكانية رئيمي رأي تأثرت المجموعات البدوية المتنقلة للنفوذ والدين. لا سيما
في منطقة جنوب الأردن ، لظت لبقة.,, أضيبعة ال يتاتل ال يمكن أن نلظت
الأهمية بالغ.

يعد عمل المشاريع البولندية مساهمة مهمة في حماية الآثار والمواقع الأثرية في هذه المنطقة، البالغ

ما يتم الاستهانة بها في يومنا هذا نظراً لطابعها المذهل، ولكن هنالك، ولكنّاً، نسبياً كأساس لتنمية معرفة العلمية.
سيسهم البحث جمع المواد التي تسمح بتطوير العلماء البولنديين في الأردن والسنوات القادمة.
ومع ذلك، تجدر الإشارة إلى أن جنوب الأردن هي دليل للكثير ليقدمه! سوف ترى عشرات من الأماكن
التي تتميز بوجود الإنسان من العصور القديمة حتى العصور الحديثة. كانت كله عواقب أكثر من أهمية العصر
القديمة، والعصر الحديث، والعصر البرونزي وعصر اكتشافات الحديد، بالإضافة إلى عدد حصر
هل من آثار من الأنبار والرومان. من أيضاً دعم ملاحظة التراث الاستثنائي للعصور
والمالبانيا البيئية المنتشرة في جميع أنحاء جنوب الأردن.
والمالباني البيئية المنتشرة في جميع أنحاء جنوب الأردن.

كان هذا المشهد الثقافي الغني لجنوب الأردن هو الذي تجتذب علماء الآثار البولنديين من علماء الطبيعة
ومرور يجوب للعلوم وأصحب مكان من ذلك عدة سنوات، موقع العلماء الأبعاد التنقيب والبحوث البيئية لأنه
لتوسيع معرفتنا حول تاريخ خيرات المنطقة وطبيعتها.

مشاريع البحوث البولندية في جنوب الأردن:
التراث | المنظار الطبيعي | مشروع مجتمعي (مشروع HLC)
بحث مخصص للبدايات في العصر البرونزي في سياق التغيرات البيئية والاقتصادية في الحقب المبكرة
الأولى.
قائد المشروع: الدكتور بيوتر كولودزيسك

البحث الأثري في مواقع الهندجة الجديدة وتوين ARTU-DTU
الأبحاث مخصصة للحقبة الرومانية والمستوطنات الرومانية القديمة في جنوب الأردن
قائد المشروع: دكتور باب روتور ياروسلاف بودزيك، دكتور كمال كوبجيج، ميز زاكوت كنز

قلاع القرون الوسطى في جنوب الأردن - قصر الدير
بحث حول المؤسسة العسكرية الرهبانية في الرهبانية الصور السوسطى في منطقة الطفيلة.
بإشراف د. برزيمي سواس نوكوي، أني السكي-شاياوكرازنويتش